Buhleo.

ROBERT BUHLER

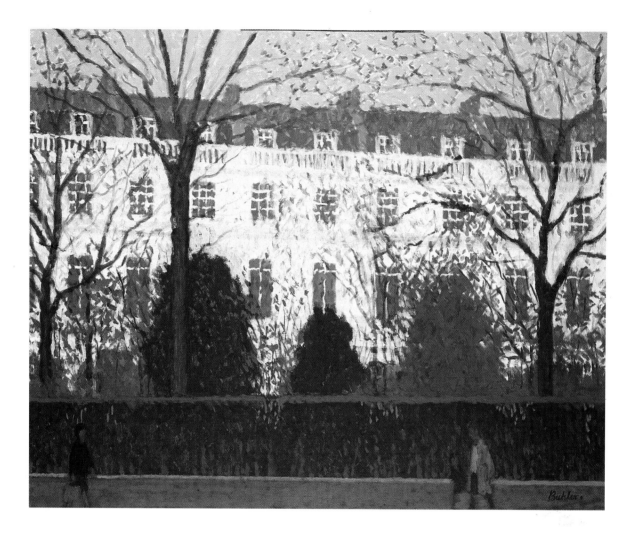

1 *Pelham Crescent* (1984)
Oil on canvas
28 × 36 in (71 × 91.4 cm)
Collection: Mr and Mrs Constantin Boden

The colour of this painting is a case of *multum in parvo*. The carefully modulated greys of the roof line, windows, road and tree trunks do a lot of work in controlling the reserved greens of the foliage, the white stucco and the lilac sky. Chromatic richness is achieved without saturation.

The Royal Academy Painters and Sculptors
General editor: Mervyn Levy

ROBERT BUHLER

Colin Hayes

Academy
Chicago
Publishers

Published in 1987 by
Academy Chicago Publishers
425 North Michigan Avenue
Chicago, Illinois 60611

First published in Great Britain in 1986 by
George Weidenfeld and Nicolson Ltd,
91 Clapham High Street
London SW4 7TA

ISBN 0–89733–240–7

Designed by Joy FitzSimmons
Typeset by Deltatype, Ellesmere Port.
Colour separations by Newsele Litho Ltd
Printed in Italy

ENDPAPERS A detail from *Tanglewood* (**57**)

FRONT COVER *Still City, Early Dawn* (1986)
Oil on canvas
40 × 50 in (101.6 × 127 cm)
Collection: G. Ware and Edythe M. Travelstead

Contents

List of Plates

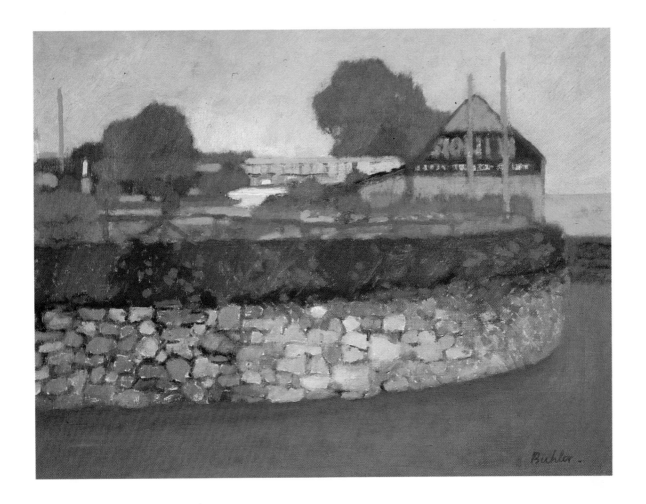

2 *Country Road, Cornwall* (1948)
Oil on canvas
18 × 24 in (45.7 × 60.9 cm)
Collection: Austin/Desmond Fine Art

An apparently simple composition which conceals
daring. The dramatic emphasis leads the viewer to the
very right-hand side of the painting and potentially out
of it altogether; but the curve of the foreground wall,
carried on by the diagonal of the gable end of the
building and the distant trees, leads the eye back into
the centre.

Biography

1916 Born 23 November at the French Hospital, Shaftesbury Avenue, London.

1926–9 Attended Westbourne Park Grammar School, London.

1929–33 School in Switzerland followed by art school in Zurich and Basle.

1933 Returned to London. Spent two terms at Bolt Court School of Photo-Engraving and Lithography. Advised to go to St Martin's School of Art where he was awarded an intermediate scholarship.

1935 Won Senior County Scholarship to the Royal College of Art. Stayed only six weeks before surrendering the scholarship. Rented a studio in Camden Town and concentrated on painting.

1936 Earned some money illustrating for the *Daily Express, News Chronicle, Night and Day,* and others. Commissioned by Jack Beddington of Shell to paint a poster depicting Hawker Hurricane fighters.

1937 Exhibited at mixed exhibitions in London at the Leger and Leicester Galleries, Wildensteins, the Redfern Gallery and the Congress of Artists. Part-time teaching at Wimbledon School of Art.

1940 Joined fire-service in Hampshire and continued to paint.

1942 Exhibition with Lawrence Gowing, Leicester Gallery, London.

1943 Exhibition with Vivian Pitchforth, Leger Gallery, London.

1944 Exhibition with Russell Drysdale, Leicester Gallery, London.

1945 Rented studio in King's Road (3 Carlyle Studios – now the Fire Station). Taught evening classes at the Chelsea School of Art and the Central School of Arts and Crafts.

1947 Elected Associate Member of the Royal Academy.

1948 Invited by Robin Darwin to teach part-time at the Royal College of Art. Gave up all other teaching.

1956 Elected full Academician.

1959 Painted murals for the Island Room of the liner *Canberra*.

1964 Moved to Norfolk.

1969 Returned to London.

1975 Resigned from the Royal College of Art. Rented studio in Sydney Close. Painted steadily and exhibited in various galleries. Travelled to the United States, Spain, Portugal, France, Switzerland, Austria, Italy and Greece. Made Trustee of the Royal Academy.

1979 Exhibition with his son Michael Buhler at Gallery 10, Modern Art, London.

1984 One-man exhibition at Austin/Desmond Fine Art, Ascot.

Commissioned portraits include: Duke of Wellington, Dame Edith Evans, Sir John Betjeman, Angus Wilson, Sir Isaiah Berlin, Francis Bacon, Arthur Koestler, Anthony Powell, Sir Lennox Berkeley, the Bishops of Oxford and London.

Represented in many British and overseas galleries and collections, including: Art Gallery of New

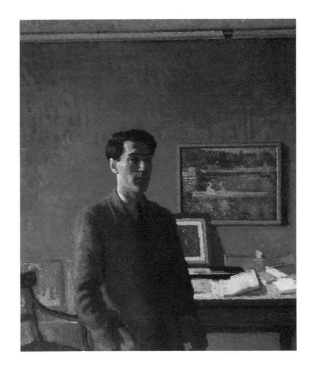

3 *Self Portrait* (1948)
Oil on canvas
35 × 31 in (89 × 78.7cm)
Exhibited Royal Academy Summer Exhibition, 1948
Collection: Austin/Desmond Fine Art

An objective view of the artist. Here Buhler has
allowed a few objects on the table, including a
painting and a palette together with a Renoir
reproduction, to reinforce the title.

South Wales, Sydney, Australia; Beaverbrook
Art Gallery, Fredericton, New Brunswick, Cana-
da; Harry Ransom Humanities Research Center,
University of Texas at Austin, USA; National
Museum of Wales, Cardiff; the Royal Academy
of Arts, London; Southampton Art Gallery; The
Tate Gallery, London.

Selected Bibliography
Books and articles about, or by, the artist:

Austin/Desmond Fine Art, *Robert Buhler RA*,
exhibition catalogue, 1984
Buhler, Robert, 'Rodrigo's Return', *Observer
Magazine* 3 September 1978
Place, G.M., 'Robert Buhler RA', *The Artist*
September 1949
Royal Academy of Arts, *Ruskin Spear RA, A
Retrospective Exhibition*, introduction by Robert
Buhler RA, 1980
Wolfers, David, 'Robert Buhler RA', *The Tatler*
1 October 1958

Radio

Robert Buhler in conversation with Mervyn
Levy. Recorded at Chelsea, 7 September 1984.
Producer Sally Lunn (BBC Sound Archives).

Robert Buhler

Robert Buhler was born in London in 1916. His parents were Swiss, his father from German Switzerland, his mother from the French-speaking canton of Valais. His father was a man of many talents. A mathematician by training, he studied in Zurich where he met and admired Einstein as a teacher. He came to England before the First World War as an aircraft designer with Handley Page; here he met and married Buhler's mother. Soon after the war he returned to Switzerland where, after an abortive attempt to start a one-plane airline, he became a periodical editor and agent for an English public relations firm which was in part a cover for British intelligence. Buhler senior soon became involved in this intelligence work from the Swiss end.

Robert Buhler relates that on his marriage in 1938, his father's wedding gift was a honeymoon in Vienna. This happy trip unfortunately coincided with the *Anschluss*, and Buhler found himself asked by his father to report on his return to London what he had seen and noted (in whatever code his amateur ingenuity could devise) of the Nazi troop dispositions. He felt that in fairness to his bride he could not tell her about this bizarre aspect of their holiday, but remembers that privately he had the uneasiest of honeymoons.

With this background and with the diverse linguistic expertise of both his parents, Buhler was brought up in a cultured mixture of English, French and German. But English, and the experience of an English boyhood, predominated. He attended the Westbourne Grammar School in London from the age of eight until he was twelve.

He had some schooling thereafter in Switzerland, but already at thirteen he was becoming preoccupied with painting (he was one of the exceptions who was actually encouraged by his father into what most parents regard as a precarious career), and entered into professional training with some months at art school in Zurich and Basle. He returned to London to attend briefly the Bolt Court School of Photo-Engraving and Lithography. Here he met Keith Vaughan, who with the school's principal encouraged him out of commercial art into what must have been seen even by then as his true vocation, painting. And so in 1934 he became a painting student at St Martin's School of Art. Here he had the good fortune to be taught by both Vivian Pitchforth and Leon Underwood. With their very differing approaches, one painterly and one sculptural, they helped to give him that broad and

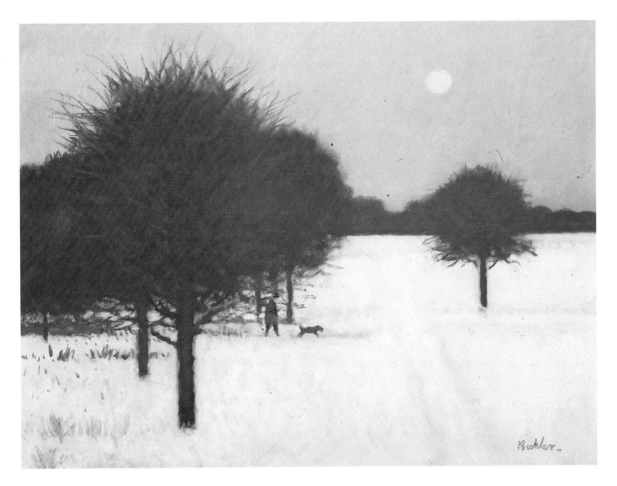

4 *Moonlight Scene* (1985)
Oil on canvas
20 × 24 in (50.8 × 61 cm)
Exhibited one-man exhibition at Austin/Desmond Fine Art, 1984
Collection: William Desmond

Recently, Buhler has painted several night scenes, or at least crepuscular subjects, in which the full moon features. Most paintings featuring night and the moon are readily held to be works of Romanticism, and while there are more than usually romantic tonal evocations in this series of his, there is nothing sentimental about them. There is that same formal placing of interval and mass that we find in his other works. The moon, with its precise placing in the design, stands as a symbol for condition of light rather than as a literal rendering. This snow scene is one such example: another is that of the dome of Sta Maria della Salute, seen from the bridge of the Accademia in Venice, *Still City, Early Dawn* (see front cover).

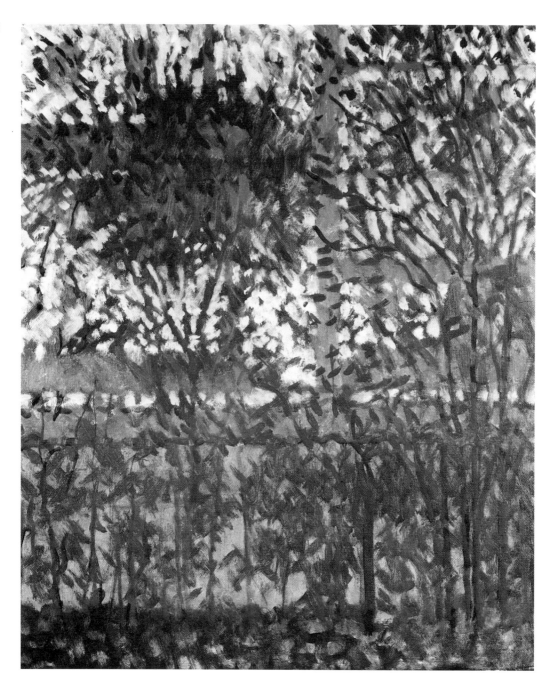

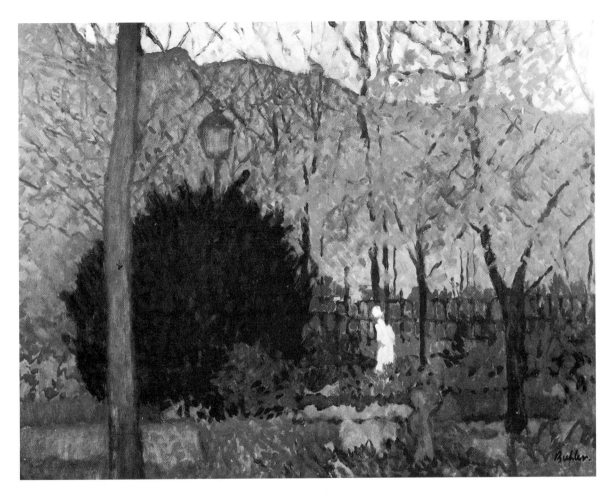

LEFT **5** *End of the garden* (1985)
Oil on canvas
20 × 16 in (50.8 × 40.6 cm)
Collection: Austin/Desmond Fine Art

As in his *Garden, Chelsea Arts Club* (**6**), Buhler uses
the greatest economy of suggestive marks to create
the sense of the rest that is there.

ABOVE **6** *Garden, Chelsea Arts Club* (*c.* 1983)
Oil on canvas
30 × 40 in (76.2 × 101.6 cm)
Collection: Austin/Desmond Fine Art

A recent urban landscape. The few expressed
branches stand duty for the many that are there; we
need no more. The four or five simple tones which
make up the contrasting masses are given added
vibrancy by the punctuation of the single white figure.

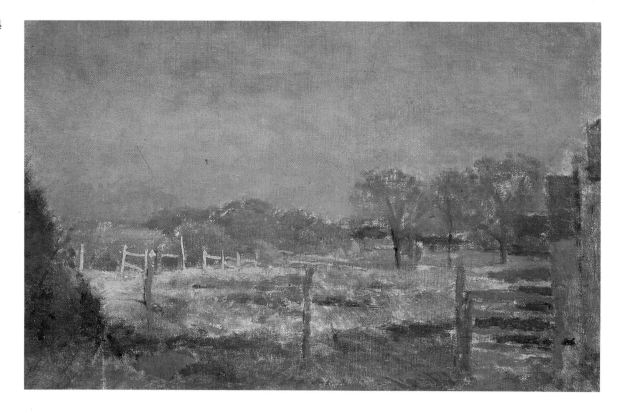

solid foundation of formal drawing which has always distinguished his work.

After St Martin's Robert Buhler went briefly on a scholarship to the Royal College of Art, but apart from his meeting with Barnett Freedman did not find the teaching there of much benefit to his needs.

This was a period of some transformation in ideas about the teaching of art, and of painting in particular. The tradition of teaching at the Royal College followed to a degree that promoted at the Slade School of Art under Frederick Brown and Henry Tonks, and under which so many teachers at the college (including William Rothenstein and Gilbert Spencer) had been trained. This tradition led to a vital insistence on the pre-eminent importance of linear structural drawing as a form of discipline in its own right. It is true that strong individual teachers gave to different colleges something of a 'house style'; and it is often easy to tell even now that an ex-student and long-practising artist had been taught at the Royal College, the Slade or under Ernest Jackson at the Byam Shaw. But (though here Jackson was an exception) it was often made difficult for a student, however accomplished he

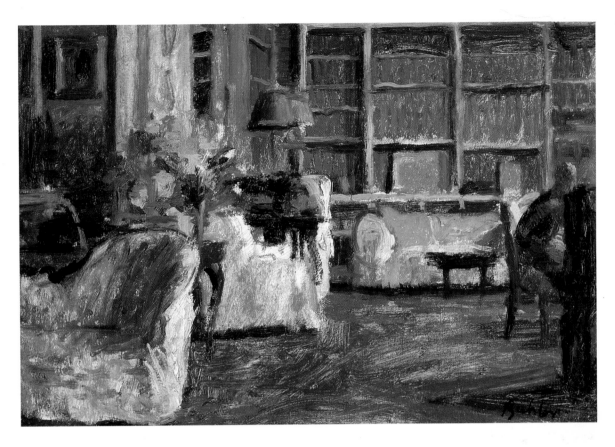

LEFT **7** *Early Spring, Rogate* (1942)
Oil on canvas
12 × 16 in (30.5 × 40.6 cm)
Collection: Austin/Desmond Fine Art

An early landscape in which some quality of Wilson Steer's romantic feel for the East Anglian countryside may be detected.

ABOVE **8** *The Library, Rockingham Castle* (1942)
Oil on board
10 × 16 in (25.4 × 40.6 cm)
Exhibited one-man exhibition at Austin/Desmond Fine Art, 1984
Collection: Mr and Mrs Winterbottom, Chelsea Arts Club

The painting of interiors, particularly if they are the drawing-rooms or libraries of country seats, poses a daunting problem; there is so much to eliminate. Turner, of course, did this brilliantly at Petworth. Here Buhler has mastered the difficulty. We sense the nature of the expansive armchairs and sofa and see that the shelves are full of leather-bound tomes. But none of this is achieved by descriptive detail.

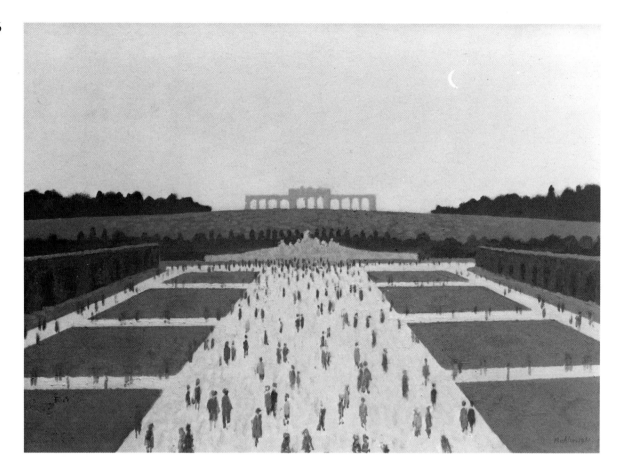

became as a draughtsman, to relate this ability to the idea of painting. It is said that at the Slade under Tonks the student might spend two or three years in the cast room and drawing from the live figure (together with attendant training in anatomy and perspective) before he was allowed to touch a brush.

Rodrigo Moynihan has recalled that in his days at the Slade the student faced with the prospect of making his first life painting was also faced with the problems of colour and tone, puzzling novelties of which he had been told little. The requirement was the establishment of a well-worked structural linear drawing on the canvas, to which colour was then to be added, often over a monochromatic tonal basis. Moynihan suggests on reflection that what they found so difficult at the time was actually pictorially impossible. No painting could really be initiated in terms of colour values by such

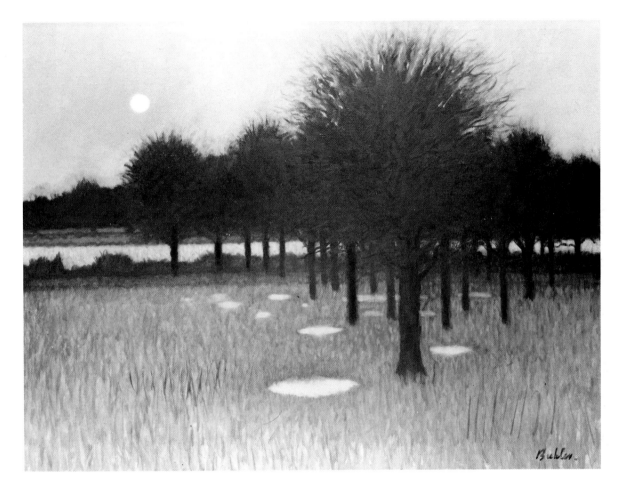

LEFT **9** *Maria Theresa Exhibition, Schönbrunn: Dusk* (1981)
Oil on canvas
30 × 40 in (76.2 × 101.6 cm)
Exhibited Royal Academy Summer Exhibition, 1981
Collection: Bankers Trust Company

The symmetrical layout of this receding perspective view leading past crowds to the moonlit distant sky is somewhat in tune with Hiroshige's *Saruwaka-cho in Moonlight*, with its street and populace led in strict central perspective to another such sky. It is unusual for Buhler to paint 'famous places' and he rarely makes use of such overtly linear perspective.

ABOVE **10** *Water-meadow: Dusk* (1982)
Oil on canvas
28 × 36 in (71 × 91.4 cm)
Exhibited Royal Academy Summer Exhibition, 1982:
Charles Wollaston Award for the most distinguished work in the exhibition
Private collection

This monumental tree silhouette is contained by hidden geometry. The mass is held by a controlling rhomboid cut through below its longer axis by the light strip of water. In relation to this simplifying geometrical order the placing of the orb in the sky and of the foreground ellipses is carefully considered.

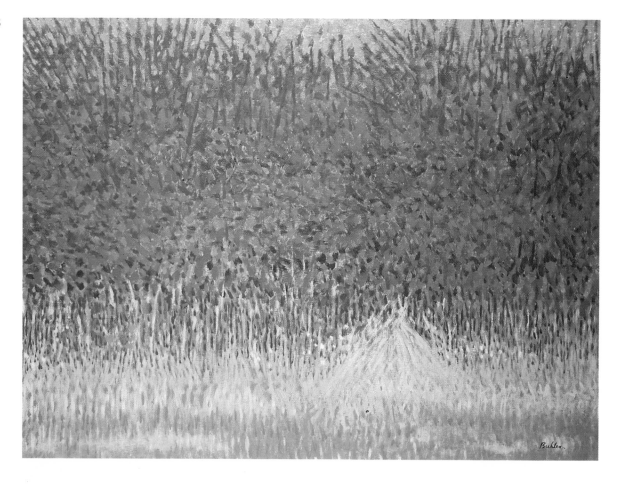

ABOVE **11** *Hedge, Cornfield, Bridgham* (1985)
Oil on canvas
30 × 40 in (76.2 × 101.6 cm)
Exhibited Royal Academy Summer Exhibition, 1985
Collection: Mr and Mrs Powell-Smith

One of the characteristics of Buhler's landscapes,
particularly of his more recent, lies in his not being at
the mercy of focal points. These he is indeed adept at
using, but in such an example as this painting he
eschews them. From the contrasting textures of
grass, leaves and flowers he builds from Nature what
is in effect a tapestry.

RIGHT **12** *Cedar Tree, Moat House, Norfolk* (1970)
Oil on board
48 × 36 in (122 × 91.4)
Collection: the artist

In this painting the simplification is so great that the
artist creates an abstracted space with a few
elemental silhouettes. The colour too is elemental, a
few modulated blues set off against yellow. Nature
has not lost its identity but has been translated into a
pure pictorial surface.

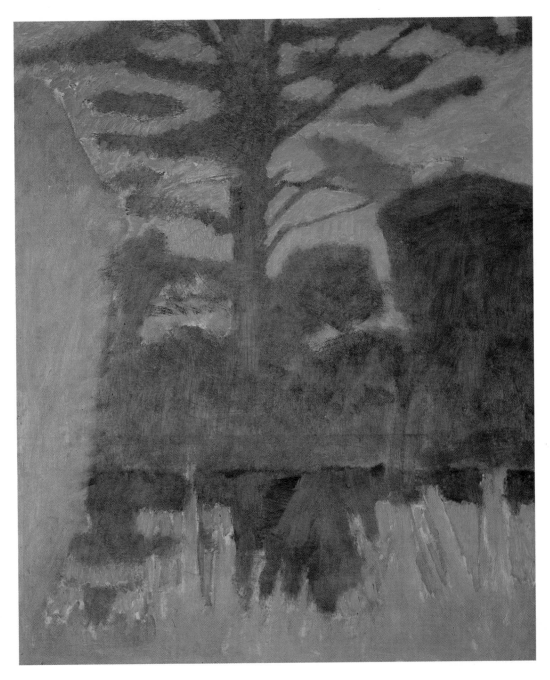

procedures. However the young rebels at the Slade and the Royal College (Moynihan was one of them) saw painting as something in its own right, with drawing as its basic handmaiden: many turned to the ideas which stood somewhat in opposition to Slade academicism. These ideas derived extensively from French Realist and Impressionist painting, and were given practical demonstration in England by Sickert and the Camden Town Group. Sickert, himself an influential teacher, regarded drawing as no less important than did Brown or Tonks. But both in his work and in his extensive critical writings we are made to grasp that drawing is something to be learned and performed for a purpose. A painter's approach to drawing will in these terms be different from that of a sculptor. A drawing is to be used, though it may be a fine work of art on its own. 'Nothing', Ernest Jackson said, 'is more boring than a drawing made to look well as a drawing.' Sickert may not quite have voiced the painter André Lhôte's definition of painters' drawing, 'Where to put the Colour', but he opened the minds of many students to the thought.

Robert Buhler entered into, and emerged from, his training at just the time when the French attitude to painting transmitted through the Camden Town Group was taking a belated hold in England and in English teaching (Scotland had had longer contact through the Glasgow School). Not least was it felt by that group of young artists associated in one way or another with the Euston Road School. Started by the young Turks of the Slade, William Coldstream and Graham Bell, the school attracted a group of like-minded painters such as Victor Pasmore, Geoffrey Tibble, Claude Rogers and Rodrigo Moynihan. Buhler did not attend the school himself as student or teacher, but, like others, got to know those who did. The protagonists had in fact a suspicion of the more flamboyant aspects of the School of Paris, but drew from French painting a sense of its pictorial unity.

Buhler's approach, even in his early painting, is already clear. His colour is restrained, but his portraits, still lifes, and landscapes are from the start constructed from the standpoint of a unity of conception. We can see in these works the hand of a painter who will never fall into the trap of making a coloured drawing.

There was in the thirties (vestiges of it survive) a feeling much propagated by the critics of art that 'English' art must be satisfied with occupying a cosy provincial backwater, unable to achieve the status of the great European movements. It might produce good draughtsmen but uncertain colourists, lacking the confidence of the School of Paris, not heirs to the Grand Manner and *la bonne peinture*. English painters would express themselves (preferably in watercolour) as Romantic landscapists or as minor Surrealists.

English culture in this period was dominated by the poets and littérateurs: a few painters, Duncan Grant, Vanessa Bell and Mark Gertler had Bloomsbury approval, but then they were part of Bloomsbury. For the most part the men of letters abetted the tyranny of Paris by seeking to impose on

13 *Man in the street* (*c.* 1982)
Oil on canvas
30 × 40 in (76.2 × 101.6 cm)
Collection: Austin/Desmond Fine Art

This is virtually an abstract chanced upon in real life,
and wittily recorded.

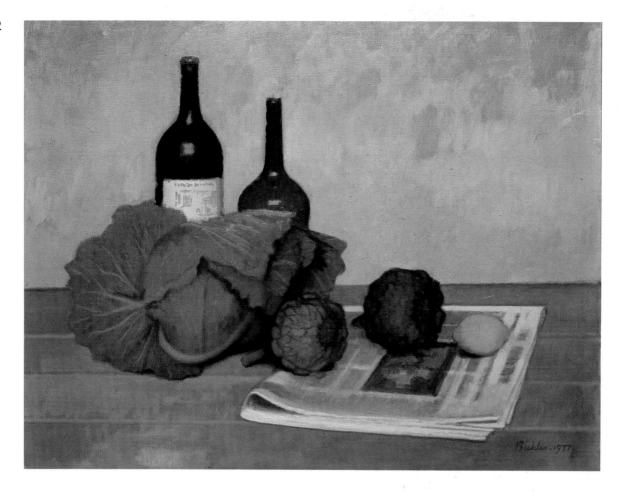

ABOVE **14** *Cabbage, artichokes and bottles on a newspaper* (1977)
Oil on canvas
28 × 36 in (71 × 91.4 cm)
Collection: Mrs Elizabeth Duckworth

In this still life and in that shown opposite, form and depth are developed with a minimum use of shadow. The individual forms are therefore seen in their characteristic entirety, not fragmented by chiaroscuro. The light tones are left free to perform their function as milk bottle, newspaper and label, the darks as wine bottles, knife blade and artichokes. All is unified by strong drawing, felt as design. Yet this unity does not rob the parts of their individuality; each form retains its own identity.

RIGHT **15** *Still life with milk-bottle* (1946)
Oil on board
14 × 18 in (35.5 × 45.7 cm)
Exhibited one-man exhibition Austin/Desmond Fine Art, 1984
Collection: Mr and Mrs Winterbottom, Chelsea Arts Club

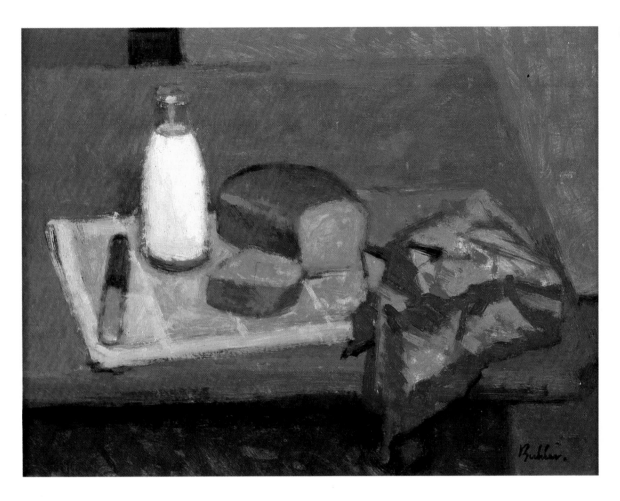

English art an inferiority complex which they by no means shared themselves. If they had an acceptable English painter of genius it was Blake, and it is difficult to recall now the near contempt in which Turner and Gainsborough were widely held. Only the status of Constable afforded some inconvenience. At the same time, the most conservative of academic painters still took an absurdly opposite view: the Impressionists were for the most part incompetent upstarts; Manet and Degas reluctantly acknowledged; but the rest, Cézanne, Van Gogh, Monet, were seen as con-men of painting. 'Loathsome Renoir, prostituting his talents,' as one such wrote.

Buhler, perhaps in part because of his cosmopolitan background, had no time for

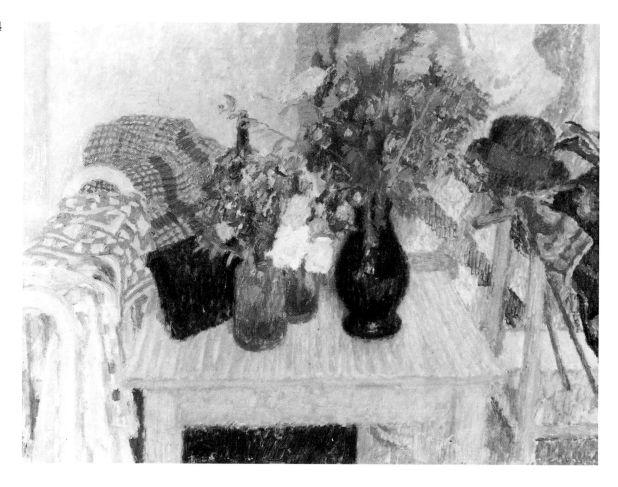

16 *Still Life* (1967)
Oil on canvas
22 × 30 in (55.8 × 76.2 cm)
Exhibited Royal Academy Summer Exhibition, 1967
Private collection

Many 'still lifes', even Cézanne's, are clearly
assembled and arranged to provide the basis for a
piece of classical pictorial architecture. Others, like
Bonnard's, look as if the painter had just chanced
upon it. This is an example of a Buhler still life which
inclines to the latter. The informality is controlled by
unobtrusive composition. As always the separate
elements are not literal but rather evocative of their
own characters. Buhler is far from what is called a
Symbolist in present-day terms: in the old sense a
symbol was a shape or mark which makes
recognizable that which it stands for. In this sense
Buhler's shapes have a strong quality of the symbol;
the vases, bottles, hats and flowers, the chequered
cloths, are all (in spite of the breadth of painting) at
once identifiable.

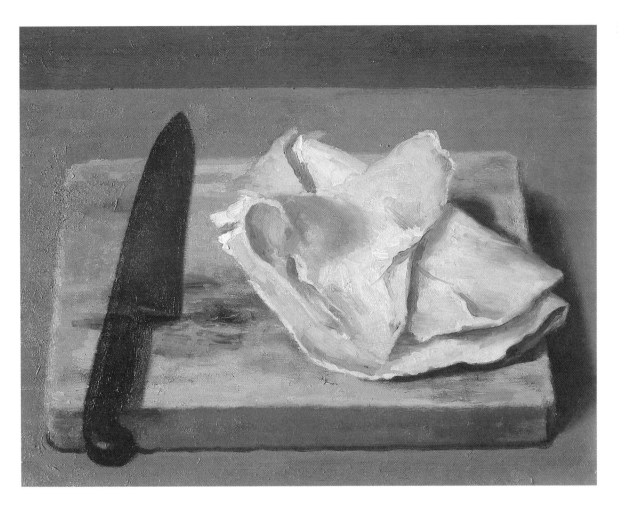

17 *Ham, knife and board* (1970)
Oil on canvas
14 × 18 in (35.6 × 45.7 cm)
Collection: Mrs Elizabeth Duckworth

An earlier still life in which the texture of paint surface
translates the differing textures of meat, kitchen board
and knife without imitation.

18 *Flower garden, Bridgham* (1985)
Oil on canvas
28 × 36 in (71 × 91.4 cm)
Collection: Lady Darwin

This recent painting typifies Buhler's concern with the conversion of literal space into pattern. The strip of water is beautifully recreated by its colour value, although there is no recourse to ripple marks, and the merest suggestion of reflections. Still water is by definition horizontal, yet Buhler in preserving its horizontality, has made it part of the vertical flat picture plane. It marries with a pattern of leaves, flowers and grass, where depth is suggested by the scale and colour of the marks, to create his characteristic sense of pictorial surface.

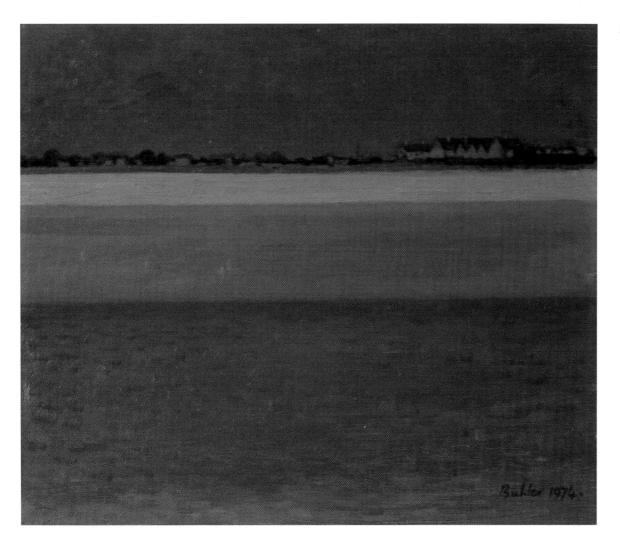

19 *Carnoustie, Scotland* (1974)
Oil on canvas
20 × 24 in (50.8 × 61 cm)
Collection: L. S. Michael OBE

Non-painters may well suppose that to paint a landscape with a minimum of incident is easier than to render one crowded with event. In fact nothing in the genre is more difficult. In this painting there exist a few distantly detectable houses and trees. Over almost the entire expanse of the canvas there is nothing but sky, water and sand-bank. This painting evokes its great sense of place and space virtually entirely by its abstract qualities of interval and value. Here again, and with a virtuoso performance, Buhler combines a moving and authentic recession of space with a frontality of the picture surface.

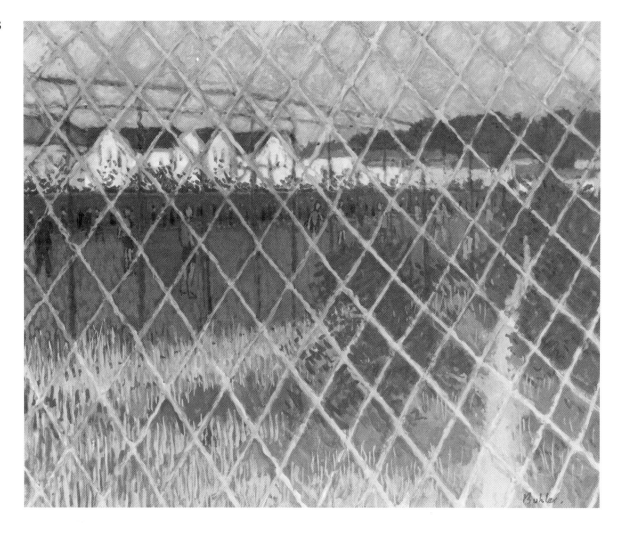

ABOVE **20** *Saturday Football* (1980)
Oil on canvas
25 × 30 in (63.5 × 76.2 cm)
Exhibited Royal Academy Summer Exhibition, 1980
Collection: Austin/Desmond Fine Art

Buhler sometimes employs the device of a view seen
through a close-up network; as here, where a
football game is glimpsed through the irregular
lozenges of a netting fence. As with the view through
a window (right), this device affords an opportunity for
playing a pictorial game of its own. While the distance
holds together as a total, each frontal aperture
contains a little painting bounded by a frame.

RIGHT **21** *Autumn Garden with Cat* (1983)
Oil on board
48 × 96 in (122 × 243.8 cm)
Exhibited Royal Academy Summer Exhibition, 1983
Collection: L.S. Michael OBE

these largely literary posturings on either side. He admired Constable and Turner as English painters but primarily as painters, and he admired the Impressionists in all their variety as the heralds and founders of twentieth-century art. Recognizing that each country will have its national character, be it England, France, Spain or wherever, he saw no reason why painting in England should not hoist itself to the highest levels, preferably by its own bootlaces.

His leaving the Royal College coincided with a small gift from his grandmother, and he used this to launch himself as a practising artist with a studio in Camden Town. He had at this time the extraneous good fortune that his mother, now separated from his father, had opened a foreign-language newspaper shop-cum-book shop-cum-cof-fee shop in Charlotte Street. Intended to serve the foreign community of Soho, it rapidly became a meeting centre for the well-known artists and writers then congregated in Soho and neighbouring Bloomsbury, among them Augustus John. Buhler not only had great talent, but it was early on recognized by men and women of influence through this connection.

As well as working in London he prepared the ground for his emergence as a landscapist, making East Anglia his hunting ground and moving from one rented cottage to another in search of fresh subject matter. This emergence was not long to be delayed. Almost his first professional job came from Jack Beddington of Shell, who used many painters as poster artists. He commissioned from Buhler a poster depicting a flight of the

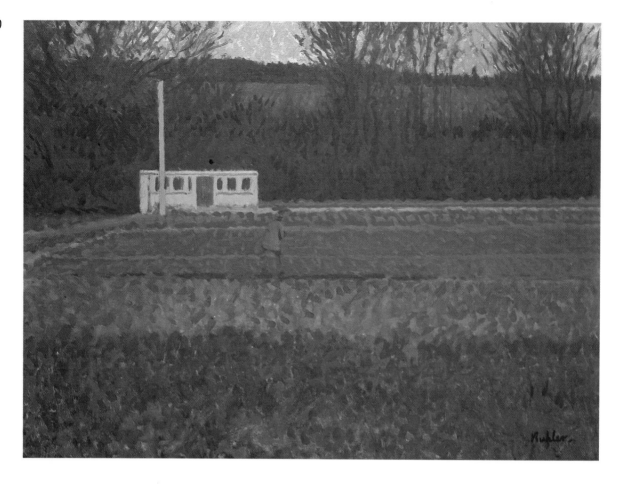

new Hawker Hurricane fighters; an uncharacteristic subject which he handled admirably (**24**). (The present writer recalls the first public appearance of this as yet unnamed machine at a Hendon Air Display: Buhler's poster admirably recalls the schoolboy thrill of witnessing this revolutionary wasp, together with its sister Spitfire, hurtling down out of the sky.)

He was exhibiting almost at once, and like many painters, was encouraged by that indefatigable patron of artists, Sir Edward Marsh. Herbert Read noted his *Portrait of Dickie Green* (**25**) in the first British Artists Congress (mounted by the Artists' International Association) and illustrated it in *The Listener*. His first big portrait success was his *Stephen Spender* which was purchased by the Contemporary Art Society. Within a short time he was making his mark and becoming

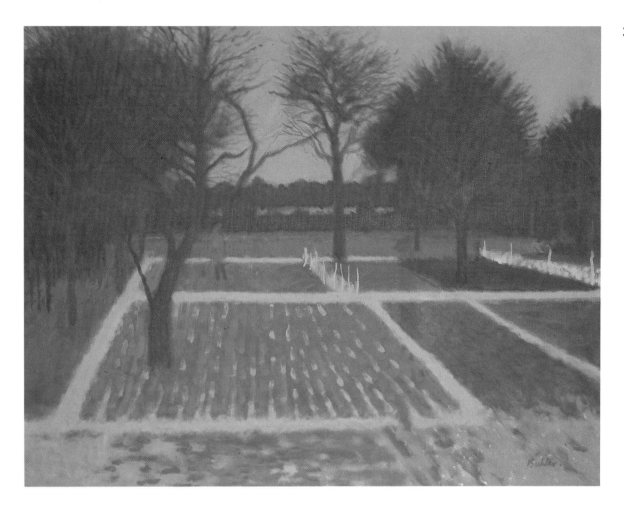

LEFT **22** *Vegetable garden, Bridgham* (1984)
Oil on canvas
28 × 36 in (71 × 91.4 cm)
Collection: the artist

In this landscape the artist has used a device for which the eighteenth-century painter John Crome was famous. A single red or orange figure not only acts as a focal point, but enhances by contrast the range of cool greens and blues which occupy the largest part of the picture plane.

ABOVE **23** *Bridgham Farm* (1982)
Oil on canvas
28 × 36 in (71 × 91.4 cm)
Collection: Austin/Desmond Fine Art

Another example of the punctuating orange figure. In this subject, though, Buhler combines the focus with a recessive perspective foreground leading the eye sharply into the distance. The figure plays a more subordinate role than in the work opposite.

FOR HIGH PERFORMANCE

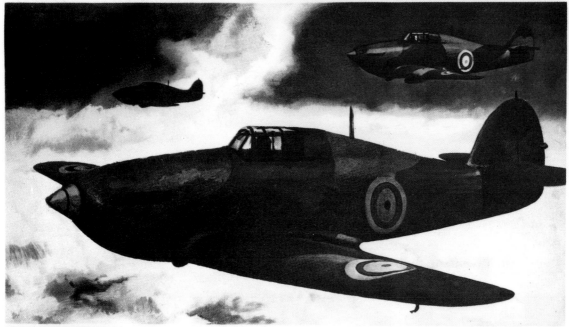

HAWKER HURRICANES

ROBERT BUHLER

LUBRICATION BY SHELL

an established painter; his work, along with that of the Euston Road fraternity, a subject of discussion in the art schools.

The war years found him in Somerset, Hampshire and Essex and then in the Auxiliary Fire Service. He continued to paint whenever opportunity afforded; with the war's end he found himself, like so many established artists, well-known but hard put to it to make an adequate living. It was not a

good moment for selling pictures. His father, who had helped him when he could with occasional cheques sent from Switzerland through mysterious diplomatic channels, had died in 1944. Like his colleagues, Buhler found himself not only a painter but a teacher. But this was not merely to eke out a living: it became evident that he was not only born to paint, but born to teach. So, in 1945 he found himself on the staff at Chelsea

School of Art along with Henry Moore, Graham Sutherland and Brian Robb (conveniently round the corner from Carlyle Square, where he moved into a house which his mother had bought). He taught also at the Central School together with Moynihan, Ruskin Spear, William Roberts, John Minton and Bernard Meninsky. It must have been a formidable though enlightened academy.

It was a period when very many of the students had emerged from war-time service, hardly much younger than some of their teachers, with a burning desire to make up for lost time and work. Matured by their service, they had mostly had enough of orders and were not to be led by the nose. They wanted to be reasoned by intelligence, sympathetic understanding and sometimes by irony, into advancing their own abilities. Buhler's talents as a teacher were admirably suited to meet the needs of such students.

The new mode of thought engendered by himself and his colleagues encouraged in students talents not necessarily made in their masters' images, but in any shape or form as long as it seemed possible to be nurtured and led towards fruition. Discipline and a need for hard work remained, but not along a prescribed track.

The energies of this teaching, in which Buhler played a leading part, were soon to be transferred from the Central School. There was some friction between the principal of the Central and his staff at just the moment when Robin Darwin was appointed the new head of the Royal College of Art. He was determined (and successfully so) in the task of leading the Royal College into the

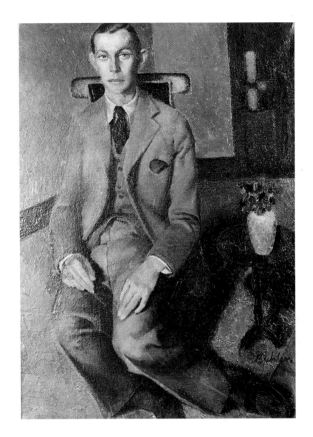

ABOVE **25** *Dickie Green* (*c.* 1937)
Oil on canvas
25 × 18 in (63.5 × 45.7 cm)
Exhibited First British Artists Congress, 1937
Private collection

LEFT **24** *Prototype Hawker Hurricane* (1937)
Oil on board
24 × 36 in (61 × 91.4 cm)
Collection: Shell U.K. Ltd (Copyright © Shell U.K. Ltd)

One of Buhler's earliest professional pieces, that commissioned by Jack Beddington of Shell.

postwar era; he was convinced that the promotion of design in all its aspects lay in the backing of the 'Fine Arts'.

Accordingly the autumn term of 1948 found Robert Buhler, with Spear and Minton, joining Carel Weight and Rodney Burn at the Royal College of Art School of Painting, with Rodrigo Moynihan as the new Professor. Darwin picked his teams both in the Fine Arts and in the new revitalized Design Schools, and wisely trusted them to get on with the job with the minimum of academic interference. This policy made for stimulating years in the Painting School, first under Moynihan and then Carel Weight. Buhler taught here from 1948 to 1975. It was not only ability and understanding of painting which made him such a valuable teacher, he also had (and has) a broad appreciation of art movements far removed from figuration.

Students of broadly differing styles and sympathies were accepted into the school – merit was never narrowly adjudged – and Buhler's own breadth of mind responded; he could detect the potential best in almost every student, and could give the advice which enlarged that student's own vision. Beyond this, his intelligence and well-read store of knowledge allied themselves to a lively curiosity about the world in general. Students learned from him not only to improve their painting but to broaden their minds.

Nevertheless, his talent and enthusiasm as a teacher have never led him to neglect his painting; it has been out of his own constant practice, facing the problems of his art, that he has justified his right to teach.

Early on in his career Buhler was described in a review as 'that confirmed countryman'. Countryman he has been and is, working for long periods of his life in the countryside. But he is also gregariously metropolitan. If it is difficult to imagine him ever far away from landscape, it is impossible to see him also as anything but a convinced Londoner. He has lived in London and left it for the country several times, but has for many recent years been firmly established in town. While his urban life has in no way diminished his fascination with landscape, it has allowed him to develop a vital aspect of his art which is hardly practical for the country-dweller, that of portraiture.

Twentieth-century criticism has not been kind to this aspect of the painter's art. The portrait has been accepted as one of the highest expressions of art if it emerges from the hands of Greek or Roman sculptors, from Alexandrian encaustic painters, from Leonardo, Raphael, Rembrandt, or from Watteau, Goya and Delacroix. But even from the many great portraits painted by the Impressionists and Post-Impressionists, few have been critically accepted as among their significant achievements. The reasons may not be too far to seek. The vast demand for portraits arising in Europe and America in the Victorian and Edwardian periods was certainly largely met by flash and skilful journeymen, flatterers of the 'Salon' kind. They did little to give this noble art a good name.

Their artistic betters, Millais, Orchardson,

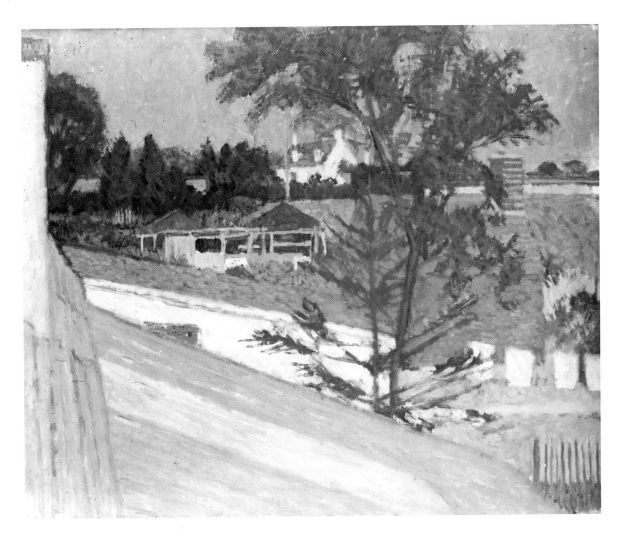

26 *Cottages – Landermere* (1962)
Oil on canvas
25 × 30 in (63.5 × 76.2 cm)
Exhibited Royal Academy Summer Exhibition, 1962
Private collection

A work of the early sixties. The vertically intruding building on the left, the dramatically sloping foreground roof and the curvilinear tree to the right, together form a frame within a frame. The detail of middle distance which it contains is held firmly in place. Buhler repeatedly used such carefully planned viewpoints as an Art which conceals Art, for the country scene remains entirely authentic.

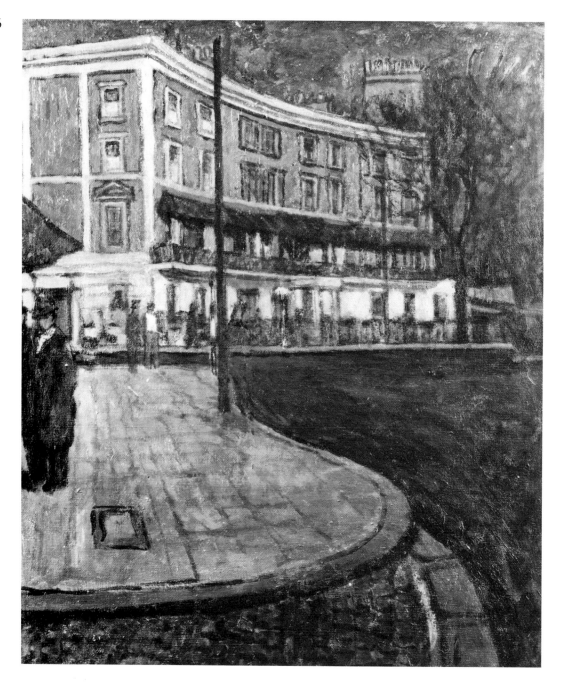

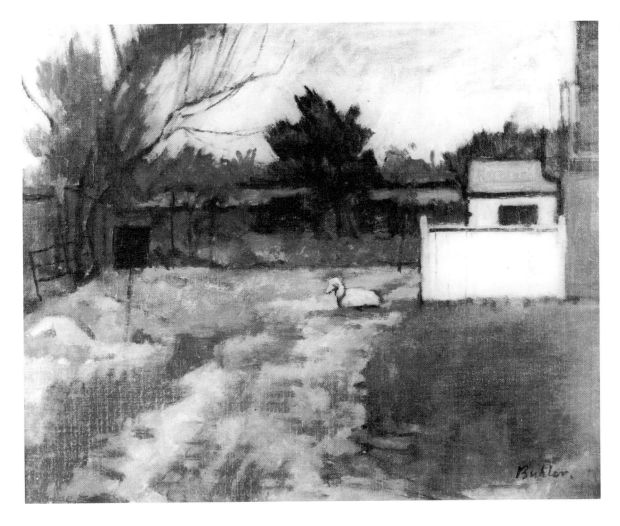

LEFT **27** *Crescent opposite Pier Hotel – Albert Bridge* (1948)
Oil on canvas
25 × 30 in (63.5 × 76.2 cm)
Exhibited Royal Academy Summer Exhibition, 1948
Collection: Mrs Jonquil Hepper

Buhler is as much at home in London as in the country, and employs the same ingenuity of design. Here the great curving sweeps of pavement, roof line and balcony are controlled by a central horizontal and vertical division of the picture plane.

ABOVE **28** *Near the Ferry Boat Inn, North Fambridge, Essex* (c. 1954)
Oil on canvas
16 × 20 in (40.6 × 50.8 cm)
Collection: Austin/Desmond Fine Art

29 *Millie Gomersall* (1936)
Oil on canvas
30 × 20 in (76.2 × 50.8cm)
Collection: Belgrave
Gallery, London

This is one of Buhler's
earliest portraits. Painted
in 1936 it shows
remarkable precosity in a
young artist. The problem
of distinguishing black
surfaces in the light from
dark shadows is not easily
solved. The painter
already does so with
confidence.

RIGHT **30** *Madge Garland*
(*c.* 1952)
Oil on canvas
30 × 25 in (76.2 × 63.5 cm)
Exhibited Royal Academy
Summer Exhibition, 1952
Collection: the artist

The artist has captured the
chic and formidable
brilliance of this celebrated
lady of the fashion world,
and managed it with an
absence of anecdotal frills.

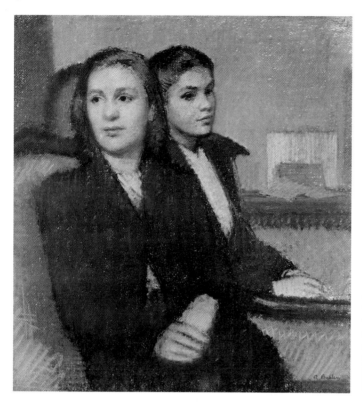

31 *Anne and Jane Hampshire* (1968)
Pastel
26 × 24 in (66 × 61 cm)
Exhibited Royal Academy Summer
Exhibition, 1968
Private collection

Buhler has made a number of double portraits, this one in pastel, a medium he uses with breadth and strength. All portraiture is difficult; double portraits pose a special problem of focus and unity. The mother and child theme is one such, but then the mother, in scale and maturity may without loss of sympathy for the child be made the dominant partner. With sisters the solution is not so readily achieved. Each must be given a fair presence and importance, yet something more than two separate portraits on the same canvas must be sought. As Gainsborough found an answer in the paintings of his two daughters, so has Buhler. He has brought the various components of the picture together to make a formal unity: this unity is carried on through the combined silhouette of the figures and the rhythmic placing of the hands. The two girls dominate the simple space they occupy; two likenesses, but a single designed event.

Sargent, Blanche and later McEvoy and Augustus John, were held to have prostituted their talents in pursuit of fame and money. But beyond this, there has been an aspect of portraiture which much criticism, in defence of its own attitude, cannot stomach; this is peculiar to our own century. Portraits, to mean anything as portraits, must be by definition figurative. They may therefore be held to represent such a challenge to abstract art, the *sine qua non* of so much avant-garde critical opinion, that even the fine portrait drawings of Picasso have been sometimes regarded as an aberrant indulgence on the part of the master.

The perils of adverse critical response never had any effect on Buhler. He has understood, where some critics do not, that a figurative likeness of an individual may be conceived and executed in terms no less 'abstract' than those of works which overtly declare their absence of subject matter.

All portraits may be criticized on painterly grounds like any other paintings – even some Rembrandts are better than others. But it has never really been possible for critical opinion to attack Buhler's portraits on the grounds nominated by its own protagonists.

They should flatter; they do not. They should sentimentalize; they do not. They should be character studies of poseurs in broad-brimmed hats and Bohemian clothes; they are none of this. Buhler's portraits are translations of the sitter, made into formal terms. He has the wit and perception to realize (like his many great predecessors) that likeness and character can in themselves be matters of abstraction.

He has himself expressed his long admiration for those Alexandrian Greek encaustic portraits which are so finely represented in the British Museum. His own portraits are in like spirit; they succeed, as do those of his remote predecessors, in combining what from their authority we accept as sympathetic likeness with what may be thought of as an almost heraldic formality.

This insistence on rendering faithfully what he sees, and translating his experience into strict pictorial terms has not always made his professional life as a portrait painter a bed of roses. No one can write more wittily on the matter of the commissioned portrait than Buhler himself, and this some years ago he did in a piece entitled 'Heads – I Lose!' for the Royal College of Art magazine – I quote him:

(None of the characters are fictitious, and all quotations are authentic.)

The desire to please is strong in most of us, and particularly when it takes the form of some exhibitionist activity which calls for a display of professional dexterity – such as is involved in painting a portrait. This exercise is doomed from the start. There are, of course, many kinds of failure, but I propose to deal only with one aspect: the failure to please.

32 *Mrs Tom Chetwynd* (1948)
Pastel
15 × 11 in (38 × 27.9 cm)
Collection: Mr and Mrs Tom Chetwynd

Another of the artist's apparently simple but subtly drawn pastels. Buhler's strong draughtsmanship gives us confidence in the placing of features: these elements of the face arise surely out of the form of the whole head to which they belong. Nothing imitative here; the truth is rendered by a translation of outward fact into marks and tonal shapes which are a pictorial equivalent. With Buhler's portraits one is always aware not only of the presence of the sitter, but, in his act of translation, of the presence of the artist. Of one late successful society portraitist it was once unkindly said that it seemed that either the sitter was never there, or that he was never there. This could never be said of Robert Buhler.

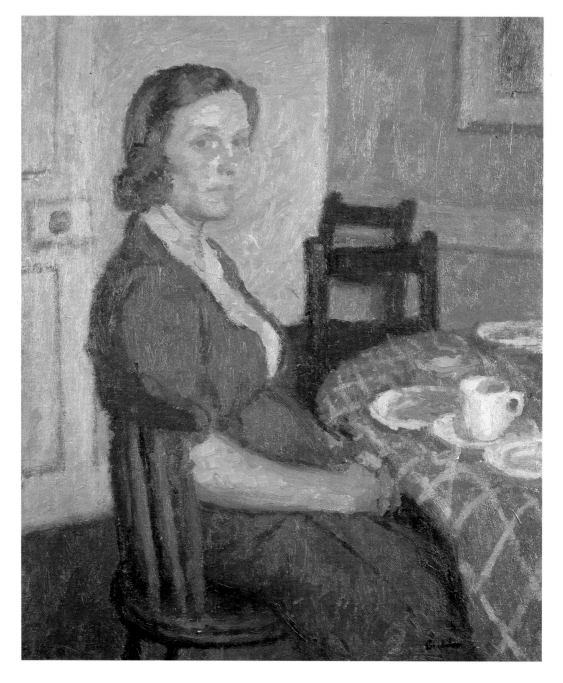

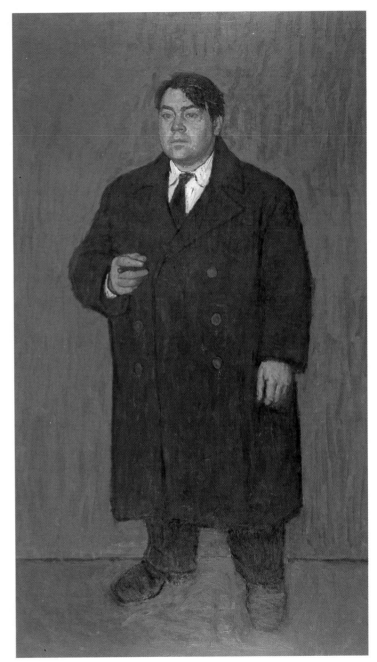

LEFT **33** *Mrs Small – Rogate* (*c*. 1942)
Oil on board
24 × 20 in (60.9 × 50.8 cm)
Collection: Austin/Desmond Fine Art

An early portrait owing perhaps
something to the example of Vuillard.
Already the artist shows how well he
can transform the anecdote of the parts
into a pictorial unity.

RIGHT **34** *John Davenport* (1952)
Oil on masonite
84 × 48 in (213.4 × 122 cm)
Exhibited Royal Academy Summer
Exhibition, 1952
Collection: Beaverbrook Art Gallery,
Fredericton, New Brunswick, Canada

This portrait of John Davenport is in
some sense a pendant to Buhler's
seated portrait of his critic friend (**42**).
Here, despite the clutched cigar,
formality predominates: there is a
Venetian quality in its simplicity and
refusal to sentimentalize. This is an
example of one of the artist's portraits
where his formal objectivity towards his
subjects approaches the condition of
heraldry.

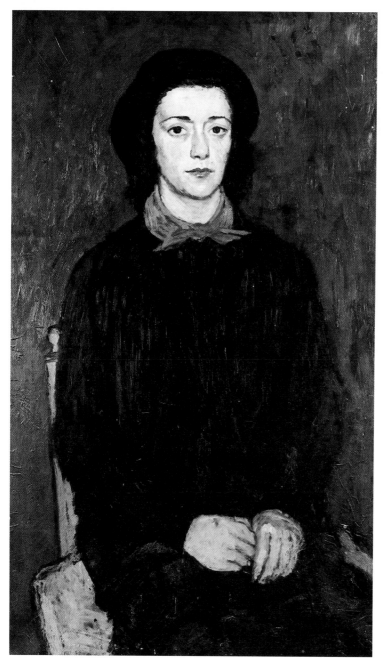

LEFT **35** *Mary Gould* (1956)
Oil on canvas
39 × 24 in (99 × 61 cm)
Collection: Austin/Desmond Fine Art

This portrait has a gravely static quality; there is an ikon-like feeling about the sitter's presence.

RIGHT **36** *Portrait of a Young Man* (1961)
Oil on canvas
42 × 56 in (106.7 × 142.2 cm)
Exhibited Royal Academy Summer Exhibition, 1961
Private collection

This is a commanding portrait. Buhler's great sense of the whole raises this, as usual, above the status of a character study to become a genuine characterization. The realizing of this formidable procession of full length facts, head, body, limbs, couch and still life, without anywhere a drifting into anecdote, shows his pictorial authority. Behind the fine drawing of such nameable elements lies his grasp of rhythmic continuity in those passages whose shapes have no dictionary name. The reserve cast shadow areas linking head, body, couch and wall are led by the tilt of the couch past hand and cap to link with the triangular halftone under the legs, and thence back along the floor. These are the passages which so easily become pictorially fragmented; not so here.

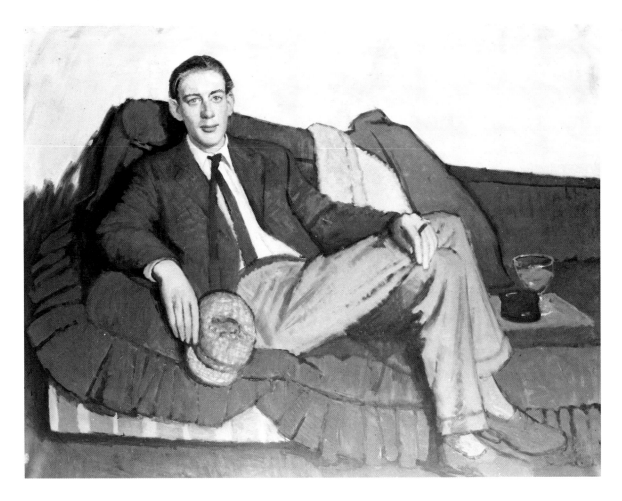

However much a patron appreciates your painting, when it comes to HIS portrait he applies certain unexpected standards – which can lead to misunderstandings. So, when a letter starts: 'We have long admired your paintings and have decided that only YOU could convey that subtle blend of John's deep commitment and outward gaiety – whilst retaining those lovely close tone values we admire so much in the "Cabbage Patch" (which we bought in 1941 at the Leicester Galleries),' you know that this portrait will founder somewhere around the mouth.

Other enquiries start more cautiously: 'We are thinking of commissioning a portrait and wonder whether you might be willing . . .' This is answered in the affirmative by return of post, and then a year may elapse before one receives the following: 'I apologize for not having answered your letter of last spring much sooner.

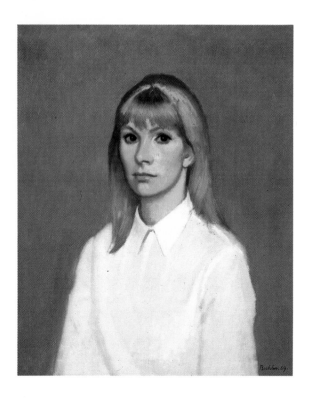

ABOVE **37** *Susan Hampshire* (1969)
Oil on canvas
30 × 25 in (76.2 × 63.5 cm)
Exhibited Royal Academy Summer Exhibition, 1969
Private collection

RIGHT **38** *Patrick Gould* (1956)
Oil on canvas
24 × 20 in (61 × 50.8 cm)
Collection: Mrs Mary Gould

This sympathetic portrait of a boy was painted in 1956 and is one of those few works the painter is prepared to feel himself moderately pleased with. The shock of dark hair, the white shirt, and rosy modelling of the face, are all built round an adjusted modulation of varied greys.

However, there was some debate as to what sort of picture, if any, we would eventually try and obtain. We went and saw your portraits at the Royal Academy some time ago, and although of course I thought very much of them, they were all I think of one single person, usually a man. What I would like to try and obtain somewhere would be a picture with both my wife and daughter, making use of contrasts in personal expression, colour etc., to achieve an effect. If you feel that such a picture could be made interesting, and is of the kind you wish to undertake, I would try and arrange for my wife and daughter to come and see you.'

This commission was duly carried out with particular attention to contrasts in personal expression, colour etc., and, needless to say, the failure lay in the effect this achieved. Another example of an enquiry received one promising spring morning: 'It is our intention to commission a portrait to be painted next year. The subject will probably be a mother and her child – approx. 2ft x 2ft 6in.' Nothing further was heard of this ambitious project, which leads one to suppose that, in this case, the shortcomings lay elsewhere.

The Adjutant of a Welsh Regiment wrote: 'We would like, as part of the celebrations of Prince Charles' Investiture at Caernarvon Castle, to commission a portrait of Capt. X to commemorate his outstanding feat of sailing the Atlantic single-handed. We would like you to paint him in his small boat in a Force 8 gale, and would wish you to pay particular attention to the leek on his cap-badge, which must be clearly visible, as well as his rank and accurate details of the rigging, and, above all, we *must* have a good likeness.' A thoughtful and deeply considered reply elicited no further signal – and this commission sank without trace.

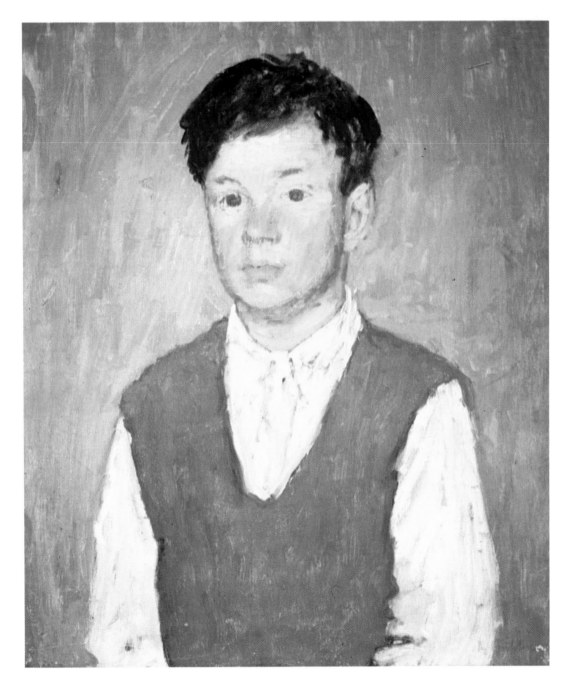

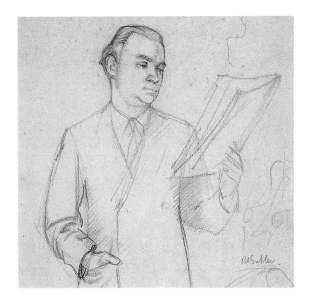

The Subscription portrait can present hazards from the very beginning when the question of a fee is raised. This can be instant failure. How is one to guess the strength of a regiment, the number of souls of a diocese, the number of loyal and devoted servants of a large corporation? The figure one quotes is either too high (there must be someone who would do it for less) or too low (it must be an inferior product). Sometimes, mercifully, there is a guiding hand in the person of the intermediary as in the case of a Diocesan Treasurer who said casually: 'Let me see, we have around 600 parishes – I think they'll cough up about £1 apiece.' Quick as a flash, 600 guineas is exactly what one had in mind. But, having got over this hurdle, let it not be forgotten that each contributor has his own strong and individual view of his candidate's benevolent appearance. However, on seeing the finished portrait, the Bishop, with true Christian humility, remarked: 'If the Good Lord saw fit to create me in this image, then I am well content. Thank you and good morning.' And off he clumped to the House of Lords. Success! – And from a high and impeccable source! But one had not reckoned with the Bishop's Lady. Swift retribution: 'The shape of the head is wrong; eyebrows, good in themselves but something wrong with their relationship to the eyes, give a look of agitation and fury; the mouth is almost right; the neck is too long; the hands are completely wrong; . . . it is best when viewed from the left – worst from the right.'

Heigh-ho! Back to the drawing-board.

The art critic of the 'Tailor and Cutter' on the portrait of a portly gentleman: 'It is difficult to know how many buttons there are on this jacket; certainly there seem to be none on the sleeves. The edges have a very thick appearance suggesting that the cloth is a heavy overcoating rather than suiting. The waistcoat has an unusual U-shaped opening, but it is very difficult again to know where the buttons are – or how many.' (Courrèges, not courage, mes enfants! [*vide* Osbert Lancaster]) On the strength of this, someone wrote: 'Now you know why I won't sit for you.'

But press on, there dawns another day: 'I think this looks a perfectly delightful picture, the colouring seems to me really lovely, but – (here it comes!) – I do not think it is like me. It's the mouth and perhaps the lower part of the face that seem to belong to somebody else as far as the likeness goes, to Disraeli I think, yes, the whole portrait is rather like Dizzy, for whom of course I have a great admiration, but whom I think I do not resemble. You must forgive my saying this, it is just the likeness which seems to have gone awry, as a picture it is beautiful, and as you know I am quite a besotted admirer of yours, if I may be

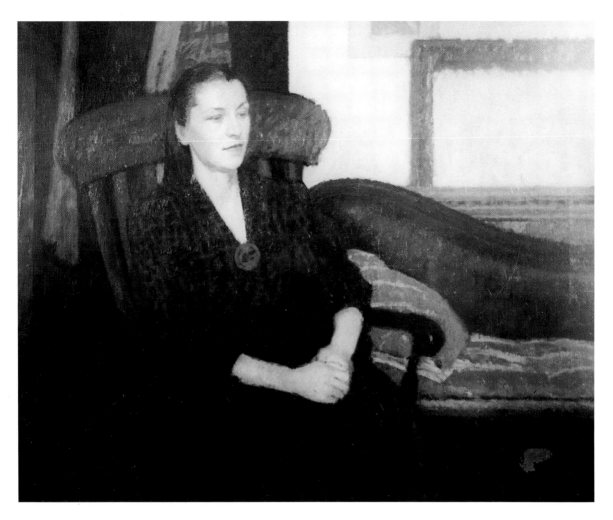

LEFT **39** *Cyril Connolly*
Pencil
9½ × 10¼ in (24.5 × 26 cm)
Collection: Harry Ransom Humanities Research
Center, University of Texas at Austin

The author's likeness and character is stated with the
greatest linear economy of means. What is necessary
is emphasized: the rest is implied.

ABOVE **40** *Lady Vickers* (*c.* 1948)
Oil on canvas
32 × 40 in (81.3 × 101.6 cm)
Collection: the artist

The sitter has a grand relationship to her setting. She
has enough space to her right not to be cramped in it,
and the large curves of the furniture introduce us to
the more compact curves of the head.

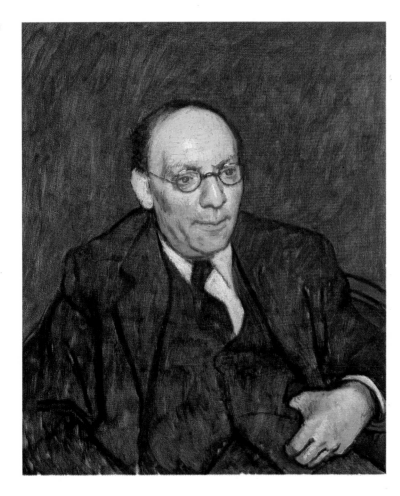

LEFT **41** *Barnett Freedman* (1955)
Oil on canvas
30 × 25 in (76.2 × 63.5 cm)
Exhibited Royal Academy Summer
Exhibition, 1955
Collection: Tate Gallery, London

This portrait of Barnett Freedman, a teacher and later friend of the artist, is one of the most deeply impressive and strongly rendered of all his works. It is a penetrating likeness; for all who, like the present writer, remember this unique character's combination of surface waspishness and deep-seated kindness, the physical and living presence of Barnett is here.

RIGHT **42** *John Davenport* (*c.* 1950)
Oil on canvas
30 × 25 in (76.2 × 63.5 cm)
Collection: the artist

John Davenport, the literary critic, was not only a close friend, but also one of Robert Buhler's favourite portrait subjects. Fine portrait painters often make hands almost as important an expression of character as faces, as the painter does here. This portrait is human informality and sympathy revealed in formal terms.

allowed to say so. What this is leading up to is, if you have any doubts about it yourself, and would like another shot at it, or another shot at the mouth, I will come and sit for you again.' This from a poetess. She came again, I shot and missed. It now looked like Gladstone!

From a popular and much respected don: '. . . and you cannot be accused of being a sycophantic admirer, at any rate of myself'.

From a businessman: 'Just wrap it up. I'll look at it later.'

From a mother about her middle-aged daughter: 'The mouth is perfect, it looks so disagreeable, but could you change the rest?'

Oh! – That ephemeral expression! – Something about the mouth, the eyes. . . . One has watched a debonair yet sardonic smile carried with great

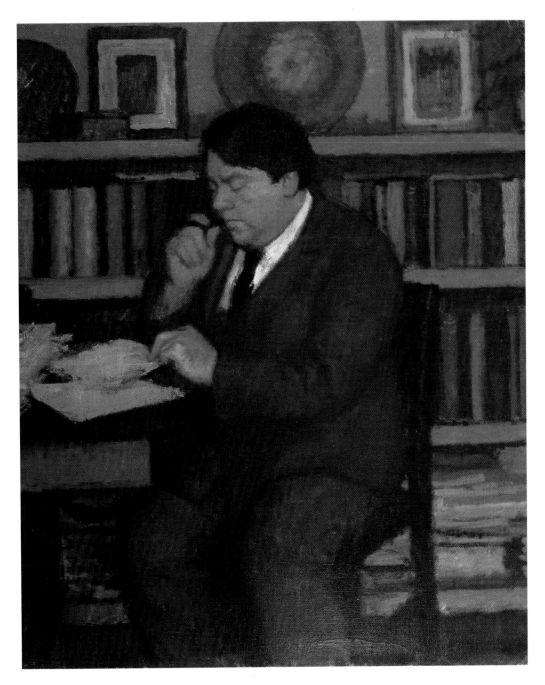

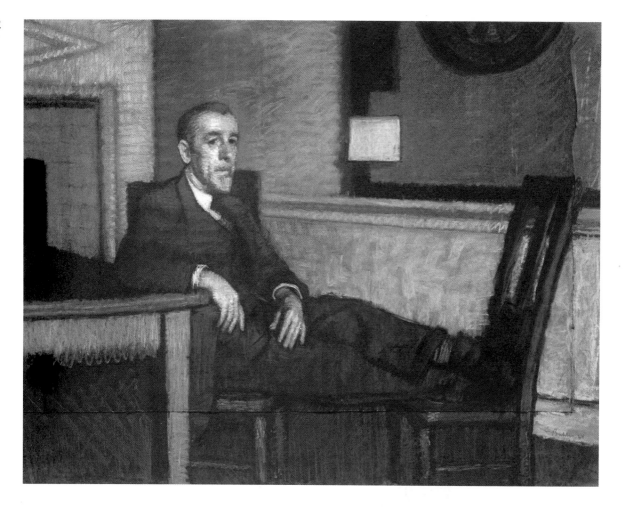

43 *Portrait of James Grant* (1949)
Pastel
18 × 24 in (45.7 × 61 cm)
Exhibited Royal Academy Summer Exhibition, 1949
Collection: the artist

This strongly wrought portrait shows how the artist
can employ the gesture of hands, as well as the
rendering of face, to establish character and likeness.
These focal points are set off by the merging of
table-top, suit, floor and chair into a single tonal mass.

RIGHT **44** *Self Portrait* (1948)
Oil on canvas
24 × 20 in (61 × 50.8 cm)
Exhibited Royal Academy Summer Exhibition, 1948
Collection: Austin/Desmond Fine Art

In this objective study of what he sees of himself in a
mirror, the artist makes no concessions to
glamorizing. When asked by a sitter what pose he
wanted, Cézanne replied 'Be an apple'; and this has
been Buhler's attitude. It is painted with more
chiaroscuro than he would normally employ today.

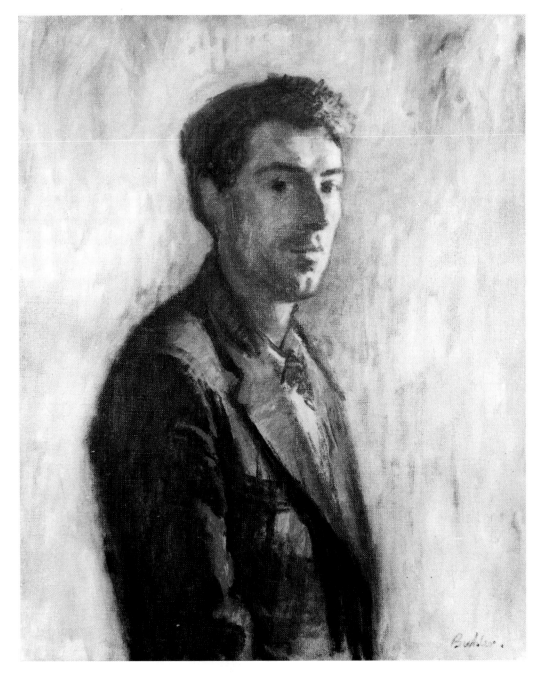

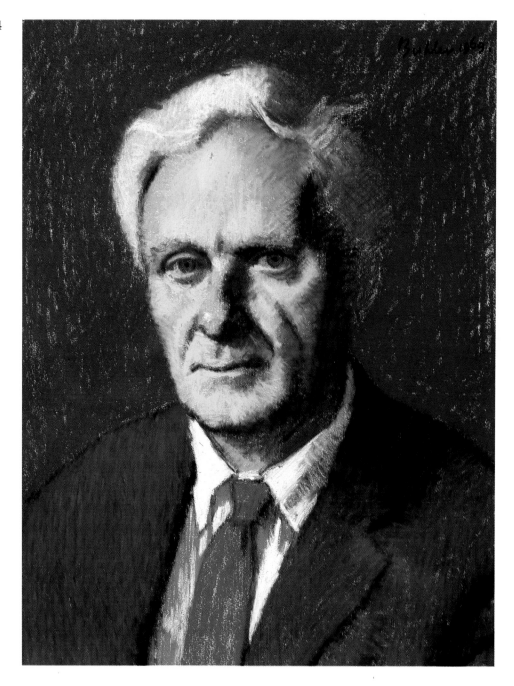

LEFT **45** *Stephen Spender* (1970)
Pastel
25 × 20 in (63.5 × 50.8 cm)
Collection: Harry Ransom Humanities
Research Center, University of Texas at
Austin

Robert Buhler is one of the few modern
masters of that difficult medium, pastel. He
has employed it to make a series of strong
portraits of his friends and acquaintances. It is
incidental but inevitable that with his broad
interest in literature and the arts, and their
exponents, many of his sitters are famous. His
interest is in faces, not in tuft-hunting. A
number of such literary portraits, some in
pastel, some in oils, are reproduced here.
Here is his friend the poet Stephen Spender,
whom he painted as a young man. This
portrayal of Spender in his middle years is in
pastel, made with an assurance of likeness
and structure; it shows a rare command of the
medium without any of the flash effects which
pastel too easily invites.

RIGHT **46** *W.H. Auden* (1970)
Pastel
21½ × 15½ in (54.6 × 39.4 cm)
Collection: Harry Ransom Humanities
Research Center, University of Texas at
Austin

care from the mirror at one end of the studio to
the chair by the window – a full 30 feet – only to
see it fade in glum surrender to the customary
expression of resigned acceptance.

Oh, how those fleeting moments pass! Whilst
the painter is measuring from the tip of the nose
to the top of the head, the chin and mouth have
quietly slipped from sight. The magic of that
studied carefree look has eluded him again –
until the next sitting?

Perhaps one's heavy load can bear comparison
with others. Of the poor colleague going down to
the country to varnish his portrait only to be told
on the doorstep that, alas, the masterpiece had
so displeased the master that he had long since
had it burnt. Or the one who had the rotten

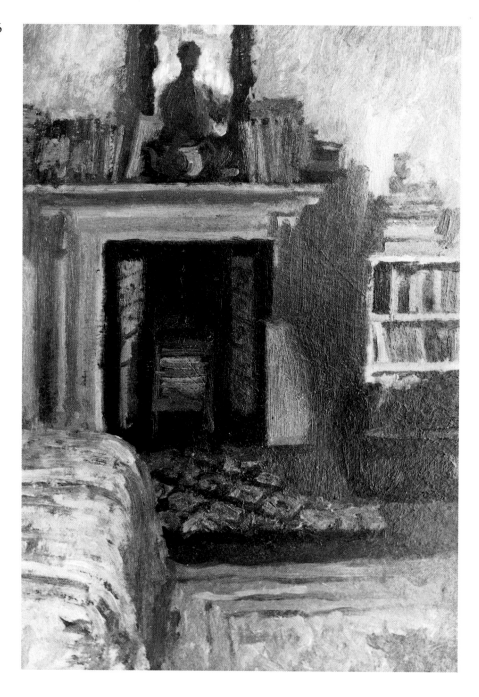

misfortune to back his car over his sitters' expensive pigskin luggage in his zeal to take them to the station after the final sitting. Or even Winterhalter, prince of portrait painters, who could do no wrong in his sovereign's eyes, who was graciously dismissed by Queen Victoria with: 'Mr Winterhalter, We are not so pink.'

Such are the tribulations of all honest portrait painters who set out to produce something more than a transposition of a flattering photograph. In fact, in spite of his own capacity for wry self-deprecation, Buhler's achievement as a portrait painter has been significant. He is one of those major artists in this country who, like Moynihan, Spear, Freud and Coldstream, have helped to restore portrait painting to its due status.

Many of Buhler's portraits are, in the words of Sir John Rothenstein, 'tributes rather than commissions'. This is to say that he has always alternated commissioned por-

traits with paintings of his friends because like Everest, they were there. Among such 'tributes' are Ruskin Spear, Francis Bacon, Barnett Freedman (**41**), John Davenport (**34, 42**), Stephen Spender (**45**), Donald Hamilton Fraser, and many other artistic and literary confrères. But his catalogue of commissions is no less glowing. He has brought the same eye and thought to bear, without compromise of observations, on Auden (**46**), Koestler, Stevie Smith, Osbert Lancaster, Betjeman (**48**) and a long parade of others.

Wilson Steer when invited to paint a portrait is said to have replied, 'I cannot paint your portrait, but I will paint a landscape of you'. Buhler's landscapes may bear little resemblance to Steer's, yet his portraiture has this kind of landscape objectivity and selectivity. Sometimes his 'sitters' are made to stand; usually they are seated in the simplest of ways characteristic of themselves. His portraits are static and monumental rather than dynamic and *mouvementé*; one might seek his examplars in Mantegna and Cézanne rather than in Rubens or Renoir.

His method is, in a sense, anti-graphic. He does not draw a likeness in line and top it up with colour. Rather out of large masses of tone and colour, placed on the canvas with an insistence on design, the particularities of face and likeness emerge in due order. It is the most demanding way in which to paint a portrait, but in success the most rewarding. It is the method of most great portraitists since the Venetians: there is a rare half-finished portrait by Ingres, that apparently most exact of detail-makers, which reveals a breadth of beginning worthy of Turner.

47 *Interior with Self Portrait* (1941)
Oil on board
12 × 16 in (30.5 × 40.6 cm)
Collection: William Desmond

Here the self-portrait element retreats, like the king and queen in *Las Meninas* by Velázquez, until it hints at the painter's presence. The four-square geometrical design reveals the tonal mystery which may be found in simple things: only the mirror tells us the room is not empty.

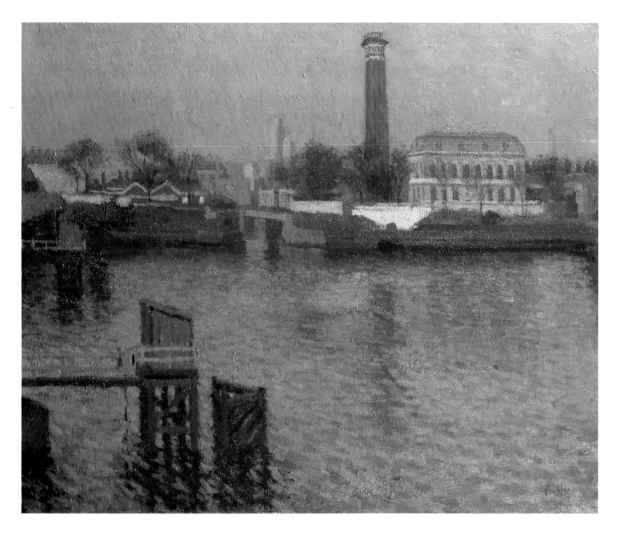

LEFT **48** *John Betjeman* (1970)
Oil on canvas
47½ × 35½ in (120 × 90.5 cm)
Collection: Harry Ransom Humanities Research
Center, University of Texas at Austin

ABOVE **49** *Pumping Station, Pimlico* (1946)
Oil on canvas
20 × 24 in (50.8 × 61 cm)
Exhibited Royal Academy Summer Exhibition, 1946
Collection: Royal Academy

Buhler has responded to this old Thames landmark in
the spirit of Monet or Sisley; but the colour with its
restrained olives, browns and luminous greys is very
much his own.

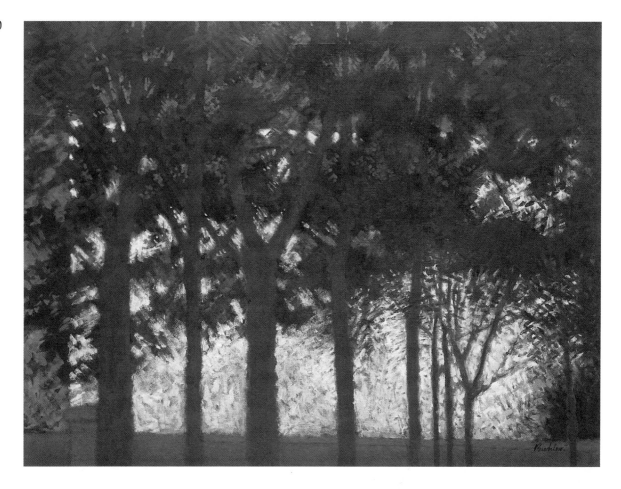

50 *London Trees* (1978)
Oil on canvas
28 × 36 in (71 × 91.4 cm)
Exhibited Royal Academy Summer Exhibition, 1978
Private collection

The multiplication of tonal values in painting is a
mounting invitation to confusion of design.
Landscape, with its great range of natural tone,
particularly tempts the artist into this pitfall.

Robert Buhler seldom uses more than four or five
broad tones to create his masses of foreground and
distance. Against such breadth, special accents of
light and dark are the more telling. In this practice he
is in the good company of most of the fine landscape
painters of the past, not least of the Impressionists.

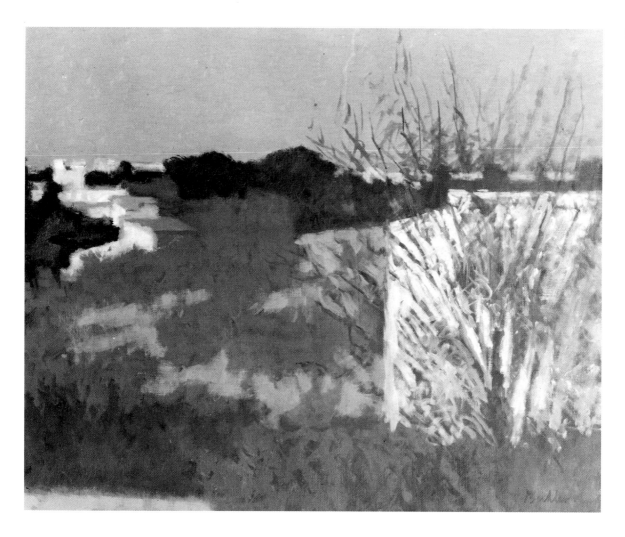

51 *Villas and Olive Trees, Algarve* (1976)
Oil on canvas
25 × 30 in (63.5 × 76.2 cm)
Exhibited Royal Academy Summer Exhibition, 1976
Private collection

This Algarve landscape is, like the plate opposite, an example of the artist's controlled tonal restraint. From his whitest paint to his blackest, no painter commands more than a fraction of Nature's tonal range. Multiplied tones must be, willy-nilly, reduced into sets. Except in the hands of an expert, the camera, which is subject to the same limitation, will reduce arbitrarily. The painter can control his choice; what goes to make Buhler's painting so individual is the way in which he does this.

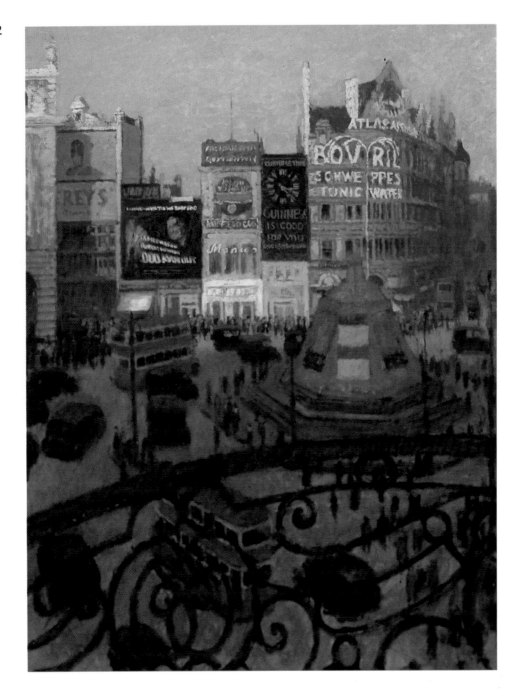

LEFT **52** *Piccadilly Circus*
(1947)
Oil on canvas
48 × 36 in (121.9 × 91.4 cm)
Exhibited Royal Academy
Summer Exhibition, 1947
Collection: Austin/Desmond Fine
Art

One of Buhler's earlier paintings,
this fine evening scene of
Piccadilly Circus as it used to be
(Sir Alfred Gilbert's *Eros* had
been boarded up against the risk
of shrapnel and bomb splinter)
would be considered by him now
to be over-anecdotal and 'Too
like a picture'. But the
anecdotes, the crowds, the
buildings, the buses, the balcony
and even the Bovril
advertisement are brought
together into a singularity of
purpose and pictorial expression.

RIGHT **53** *Early morning,
Venice* (1978)
Oil on canvas
40 × 40 in (101.6 × 101.6 cm)
Exhibited Royal Academy
Summer Exhibition, 1978
Collection: The Hon. Mrs
Mosselmans

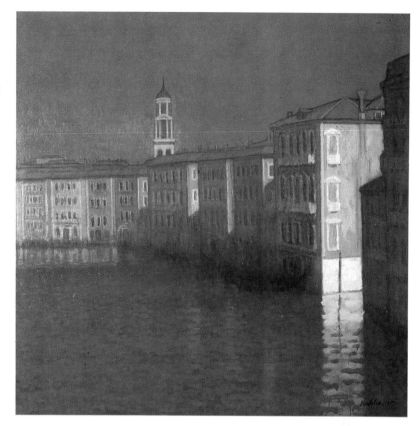

Buhler works in the tradition of painterly portraitists.

His painting has developed over the years to become more and more concerned with the language of its own craft. He loves his subject, but mistrusts 'subject matter': he has become resolute in rejecting the literary and merely illustrative in his work. Two of his fine earlier canvases are *Piccadilly Circus* (**52**), and *Pumping Station, Pimlico* (**49**). He would not paint them now, and is reluctant to acknowledge their virtues: they are, from his present standpoint, too like 'subject pictures'.

His 'subjects' have become increasingly simplified. He painted his landscapes *en plein air* until he found that he was not in his own view being selective enough. Now, he creates the same sense of place and country-side from drawings and colour notes, in his London studio. His landscapes have been by no means confined to England: he has painted in France, Spain, Italy, Austria, Greece and Switzerland. All this experience,

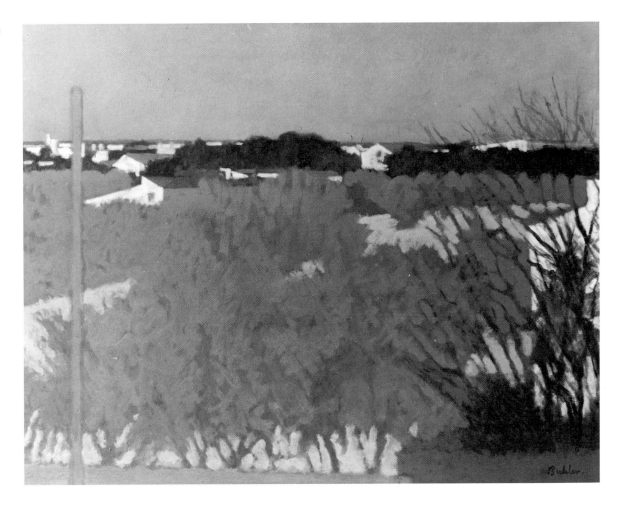

54 *Olive trees near Portimão* (1976)
Oil on canvas
28 × 36 in (71 × 91.4 cm)
Exhibited Royal Academy Summer Exhibition, 1976
Collection: Mrs John Skeaping

In this Portuguese landscape, only two brief diagonals
denote linear perspective: the others echo this
perspective direction as frontal sloping roofs. The
sense of distance is created by tone, scale and
horizontal interval.

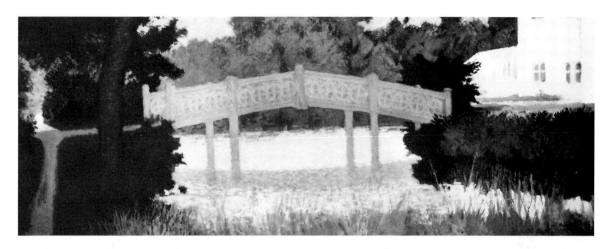

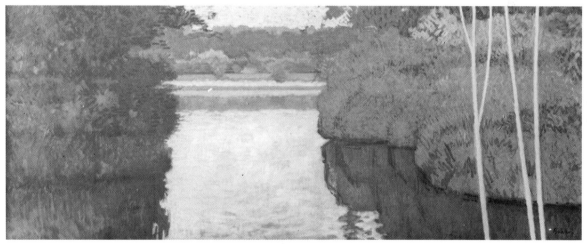

TOP **55** *Chinese Bridge – Moat House* (1970)
Oil on board
36 × 72 in (91.4 × 182.8 cm)
Exhibited Royal Academy Summer Exhibition, 1970
Collection: Sheppard Robson – Architects

Within this unusually lengthened format, sky and
foreground unnecessary to the essential subject are
excluded, and the eye is led from the shadowy
suggestion of a path on the left, across the wooden
bridge, to the greenhouse and building on the right.

ABOVE **56** *Moat House, Hethel, Norfolk* (1975)
Oil on canvas
36 × 72 in (91.4 × 182.8 cm)
Exhibited Royal Academy Summer Exhibition, 1975
Collection: Trevor Dannatt RA

Like the painting above it, this is a composition of
extended horizontal format, where the foreground tree
forms serve as a proscenium arch to take our
attention past an uncluttered stretch of central water
to the distant woodland.

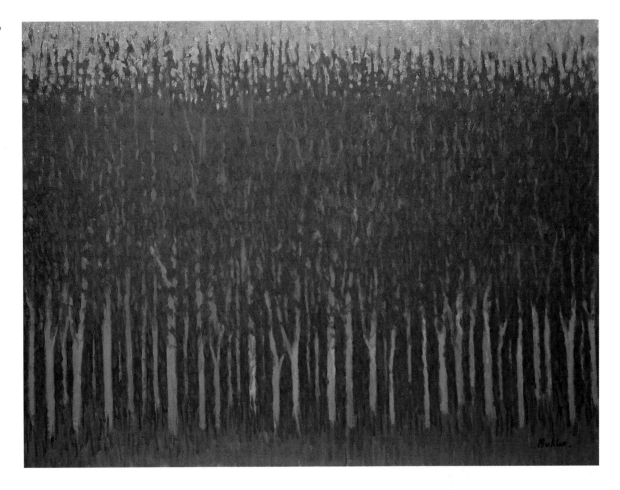

ABOVE **57** *Tanglewood* (1984)
Oil on canvas
30 × 40 in (76.2 × 101.6 cm)
Exhibited Royal Academy Summer Exhibition, 1984
Collection: Mrs Noel Parsons

This recent painting of silver birches is a veritable
translation of the actual into the abstract. Its impact
depends not only on its relation of elemental colour
values but on its precise observation of interval.

RIGHT **58** *Spring Trees* (1983)
Oil on canvas
20 × 24 in (50.8 × 61 cm)
Collection: Lady Darwin

As in so many of the artist's more recent landscapes,
incident here is reduced to the slightest. The subject is
overtly a bank of trees with a hint of distance. The
subject, more subtly, is the tonal and colour
interchanges which the bank generates. The surface
is a play between cool sky, warm lights and cool
shadow, punctuated by a few highlights.

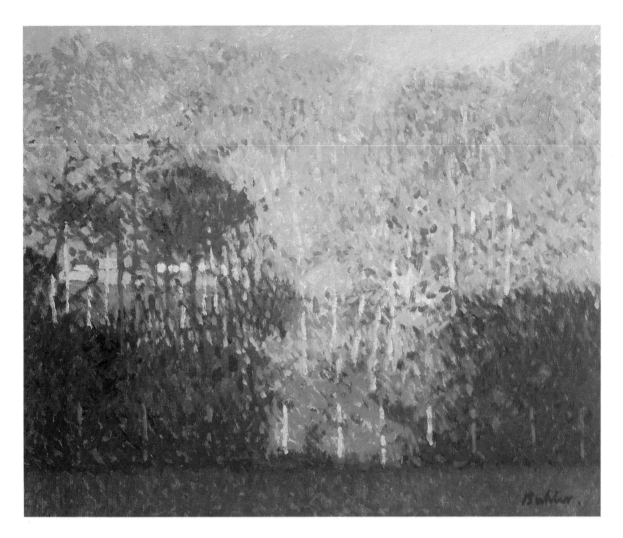

as befits his cosmopolitanism, has given his work a Mediterranean flavour; a sense of Post-Impressionism is strongly present in him.

Hazlitt, in his role as art critic, once said of a painting by Turner (surprisingly of the comparatively detailed *Burial at Sea*) that: 'It is a painting of nothing, and very like.' Something of this may be said of the present work of Robert Buhler, not in criticism but in praise.

Wherever he finds his motifs, in landscape, in portraits, in still life, it is distillation and essence which matter to him. There is

68

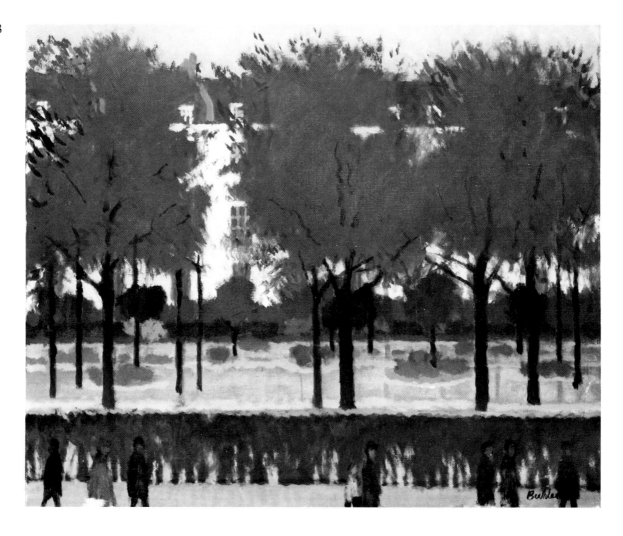

59 *Pelham Crescent* (1985)
Oil on canvas
20 × 24 in (50.8 × 61 cm)
Exhibited Fosse Gallery, Stow-on-the-Wold,
Gloucestershire, 1985
Private collection

In nearly all his painting Buhler has made the
minimum use of receding linear perspective to create
space. Here he creates it by the carefully timed impact
of contrasting silhouettes. He employs in his own way
the Renaissance method of doubling up the limited
focal range available to the painter, by jumping
alternately from light to dark and back to light in order
to lead the space forward. The halftone of the tree
silhouettes holds all together, so carefully observed
that the trees have no interior modelling; they do not
need it.

60 *Trees, Sydney Close*
(1982)
Oil on canvas
36×36 in (91.4×91.4 cm)
Exhibited Royal Academy
Summer Exhibition, 1982
Private collection

An evocation of a London
square created purely
with interval and
contrasting pattern.

nothing generalized or sketchy about his work, and if anything he has come more and more to mask rather than reveal his great facility and dexterity: but within his thoroughness he eliminates all that is not to the point of what he wants to say.

He has always been a pictorial composer of the best. He does not warp his subject into some artificial and self-conscious straight-jacket called 'design'; rather, he detects and resolves that design which is inherent in the subject itself – those intervals, proportions, directions and masses of tone and colour value which most tellingly express the essence of what is there. His sense of classical order which he brings to bear on his natural geometry enhances and does not diminish this essence of motif.

There can be in the work of some practised painters a complacent insistence on con-

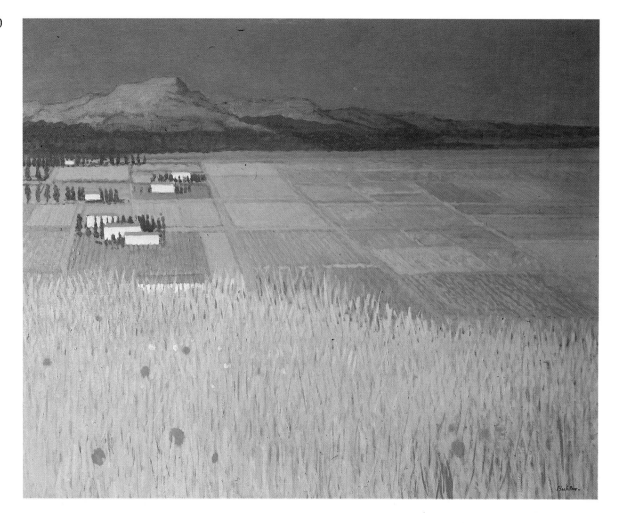

trived rules of composition which make, say, a proportion of sky to landscape predictable and therefore boring. Such proportions in Buhler's paintings are not boring, but moving. He is increasingly concerned with a pictorial translation of fact into pattern and (were it not a spoilt word) abstraction, in which the ethos of place or person is fully expressed, but where the canvas exists in its own right. Because of this he makes so much of often the apparently simplest of elements.

'Painting', he has written of himself, 'should need neither explanation nor description – it should be self-evident through the language of paint.'

Acknowledgements

The author and publishers would like to thank Robert Buhler for his unsparing co-operation in the preparation of this book. They would also like to express their gratitude to William Desmond of Austin/Desmond Fine Art, Sir John Rothenstein and the following individuals, galleries and organizations for their help and for permission to reproduce works in their collections: Bankers Trust Company; Beaverbrook Art Gallery, Fredericton, New Brunswick, Canada; Belgrave Gallery, London; Mr and Mrs Constantin Boden; Mr and Mrs Tom Chetwynd; Trevor Dannatt RA; Lady Darwin; Mrs Elizabeth Duckworth; Mrs Mary Gould; Mrs Jonquil Hepper; L.S. Michael OBE; The Hon. Mrs Mosselmans; Mrs Noel Parsons; Mr and Mrs Powell-Smith; Harry Ransom Humanities Research Center, University of Texas at Austin, USA; Royal Academy of Arts; Mr and Mrs Schachter; Shell UK Ltd; Sheppard Robson – Architects; Hugh J. Simmonds CBE; Mrs John Skeaping; Trustees of the Tate Gallery, London; Frank Thurston and the Royal College of Art; G. Ware and Edythe M. Travelstead; Mr and Mrs Winterbottom, Chelsea Arts Club.

LEFT **61** *Mistral Plain* (1986)
Oil on canvas
40 × 50 in (101.6 × 127 cm)
Exhibited Royal Academy Summer Exhibition, 1986
Collection: Hugh J. Simmonds CBE

This recent southern French view is deceptively simple. The textbooks on landscape may explain how tones become darker and more contrasted as they advance from distance to foreground. Here Buhler has reversed the process, successfully massing his darkest tones in the distance, allowing the eye to pass straight across the restrained sunlit foreground of poppies and grass and across the fields to the line of distant hills. A few poplars and white farm buildings on the left help guide and control this sense of recession.

Index

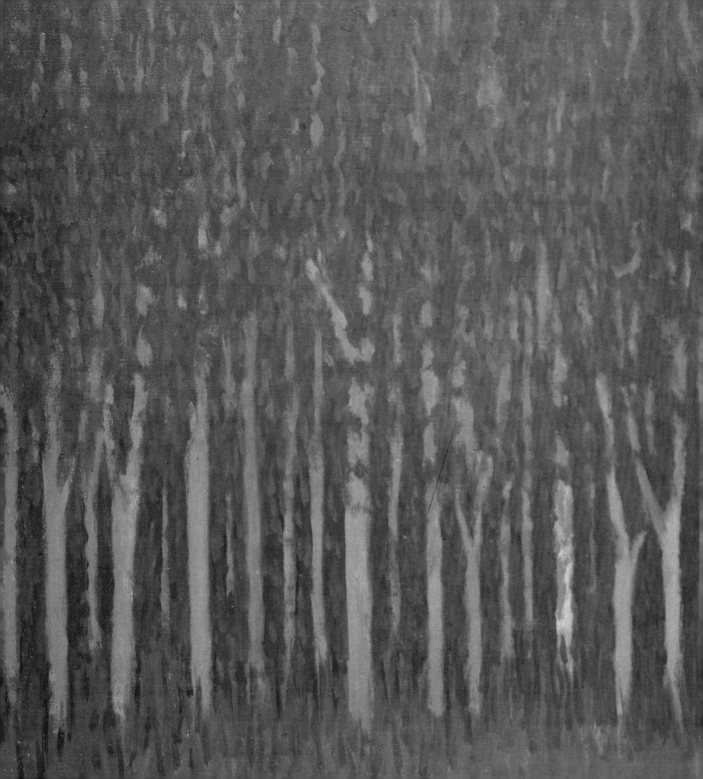